THE REVELATION OF A
MYSTERY

Getting to Know Your Bible

DR. FRANCES WRIGHT-HARRIS

WESTBOW
PRESS
A DIVISION OF THOMAS NELSON
& ZONDERVAN

WestBow Press books may be ordered through booksellers or by contacting:

WestBow Press
A Division of Thomas Nelson & Zondervan
1663 Liberty Drive
Bloomington, IN 47403
www.westbowpress.com
1 (866) 928-1240

Because of the dynamic nature of the Internet, any web addresses or links contained in this book may have changed since publication and may no longer be valid. The views expressed in this work are solely those of the author and do not necessarily reflect the views of the publisher, and the publisher hereby disclaims any responsibility for them.

Any people depicted in stock imagery provided by Thinkstock are models, and such images are being used for illustrative purposes only.
Certain stock imagery © Thinkstock.

ISBN: 978-1-4908-2113-9 (sc)
ISBN: 978-1-4908-2114-6 (e)

Library of Congress Control Number: 2013923724

Printed in the United States of America.

WestBow Press rev. date: 3/10/2014

CONTENTS

DEDICATION

I thank God for inspiring me to study the epistle of Romans. I thank Him for the wisdom and knowledge that He imparted to me during my study. Without it, this book would not be possible. I acknowledge the most important people in my life, my parents; Elder Ossie, Sr. and Julia Wright who have both gone on to be with the Lord, but left a legacy of love and teaching that reigns in me and my siblings. This book is dedicated to my siblings; Julius Wright, Dr. Mary Dixon, Bishop Ronald E. Wright, Sr., my pastor, in loving memory of my brother Ossie Wright, Jr., and to all who encouraged me throughout my lifetime.

PREFACE

Is the Bible to you ancient or outdated? Many think so today. We live in a period of time in which it seems the more freedom we have the less God conscious our society becomes. We've gone from *In God We Trust* to our own way of thinking and living. We've moved from liberation movement to liberation movement: Civil Rights, Women's Liberation, Abortion Rights, Sexual liberation, Gay Liberation, etc. While some of our new found freedoms are good, some of them are not because they go against everything God teaches us through His Holy Word, the Bible. Proverbs 9:10 says, "***The fear of the Lord is the beginning of wisdom…***" This is a reverential fear of Him that is in the foundation of knowledge. It begins with the creation. He created everything. In the foundation of knowledge, we shouldn't have trouble understanding that since He had the power to create everything, He has the power to destroy everything. No creature is greater than his creator. God is our creator so it would be wise for us to respect His power and authority, to search Him out, and get to know Him. Everything that He created, He created with a purpose in mind. In searching the scriptures, we get to know Him and learn what our purpose is. "***What has been is what will be, and what has been done is what will be done; there is nothing new under the sun***." (Ecclesiastes 1:9)

INTRODUCTION

The book of Romans is said to be the most comprehensive revelation of what Christianity is. Study it and you will find it an eye-opening, awakening spiritual gift to the believer. At the time of Paul's ministry, the New Testament had not yet been written. Little did Paul know that he would be purposed to write half of it. God's chosen vessel would have the job of writing epistles to the churches in Rome, the Galatians, Corinthians, Ephesians, Philippians, Colossians, Thessalonians, and epistles to Timothy, Philemon, Titus and possibly Hebrews. He wrote the epistle of Romans to the Jewish and Gentile converts in Rome explaining God's plan of salvation under the New Covenant. He was the first to put in concise writing the discipline for the Christian faith. He calls it the unveiling of a mystery kept secret since the world began (Romans 16:25). It brings together in one book what God commanded, what the prophets of the Old Testament preached and how it was fulfilled through the Lord Jesus Christ. We can say that Paul, God's chosen vessel, wrote the handbook of discipline for the Christian faith. While this letter was addressed to the converts in Rome, it was for the benefit of all nations and generations to come.

Before you begin your study of Romans with this exposition, please be aware that it teaches us to be VICTORS not victims. When I was doing some of my research, I found this information at http://bound4life.com/ and The Guttmacher Institute http://www.guttmacher.org to be valuable and informative: *Nearly eight in 10 U.S. women obtaining an abortion report a religious affiliation. Forty-three percent are Protestant, 27% are Catholic and 8% are other religions. Forty-one percent of women having abortions are white, 32% are black, and 20% are Hispanic. While black women appear to be a lesser offender than white women, Blacks represent only 14% of the general population. From 1973 to 2004, nearly 30% of the black population was erased through abortion.* According to reports, since Roe vs. Wade 1973, more than 45 million babies have been legally aborted. Would there have been fewer abortions if Roe *vs.* Wade were not a law giving women the right to choose? I don't know, maybe, maybe not. There are pros and cons to Roe *vs.* Wade. While it makes it easy for women to abort babies, it made it possible for them to go into a safe, sterile environment instead of a back alley to let an unlicensed butcher earn his keep by killing unborn babies and sometimes ruining their

lives or causing the death of the mother, too. What disciplines our lives and keep us from sexual immorality, abortions, and senselessness? Who gives us the victory over sinful flesh?

In other studies, the latest statistics (2013) reveal that worldwide over 1 million people have died from HIV/AIDS this year and over 35 million people are infected with HIV/AIDS. (http://www.worldometers.info/aids/) More than 1.1 million people in the United States are living with HIV infection, and almost 1 in 5 (18.1%) are unaware of their infection. An estimated 15,529 people with an AIDS diagnosis died in 2010, and approximately 636,000 people in the United States with an AIDS diagnosis have died since the epidemic began. (*Centers for Disease Control and Prevention*) Gay, bisexual, and other men who have sex with men (MSM) of all races and ethnicities remain the population most profoundly affected by HIV. Worldwide, it is estimated that more than 16 million children under 18 have been orphaned by AIDS. CDC's new estimates (2013) (*http://www.cdc.gov/hiv/statistics/basics/ataglance.html*) show that there are about 20 million new sexually transmitted disease infections in the United States each year, costing the American healthcare system nearly $16 billion in direct medical costs alone. America's youth shoulder a substantial burden of these infections. Today, one in four young women has a venereal disease. Our society's morality has decayed, so "*Are we repeating errors of the past because in our own wisdom, we've become fools*" as Paul described in Romans 1:22. Some of our freedoms have come with a high price. I doubt that these were the kind of rewards we were expecting from sexual liberation?

It is odd to me that different organizations teaches young people abstinence as the best way to prevent them from getting sexually transmitted diseases, which is what God taught mankind after the earth had been sufficiently populated. How is it that we can even begin to think that the Holy Bible is out-dated and ancient? The Bible teaches us to abstain from sex until marriage, to live one man to one wife, and avoid if possible divorces, and doesn't stop there! It teaches us how to conquer sinful flesh so that we are not plagued by senseless diseases.

God's plan of salvation gives us power over sin, but if when we come to Christ we don't use it, we remain slaves to sin. This is why we have people who call themselves Christians committing the same sins as sinners. With His plan, we can enjoy living disciplined lives. When God taught Paul the answer, he said in Romans 8:1 NKJV, "***There is therefore now no condemnation to those who are in Christ Jesus, who do not walk according to the flesh but according to the Spirit.***" Paul teaches us to live a life of victory so that we can move into our destiny which is ultimately fulfilling our purpose for the Father. St. John 8:36 say, "***So if the Son makes you free, you will be truly free.***" Jesus came to set the captives FREE! The captives are not just those bound in prison, but anyone in the bondage of sin. "***Who gave himself for our sins, that he might deliver us from this present evil world, according to the will of God and our Father:***" (Galatians 1:4) We all inherited the sinful nature of Adam

and remain sinners until we accept by faith God's son, the sacrificial lamb that paid our sin debt. God's plan of salvation gave us power over death. How so? One day the dead in Christ will rise from the grave, take off mortality and put on immortality and spend eternity with Him. (*I Thessalonians 4:16*)

I wanted to learn more about the Christian doctrine so God inspired me to study and do this exposition of the book of Romans for the benefit of myself and others so that we could understand better the discipline of our faith. There are so many Christians that don't understand their own religion. I find it rewarding. With the help of the Lord as I read and study, He enlightens me. I've learned that the more of "*I*" (the old man) that I let die the more like Him I become. I wouldn't trade where I am now in Christ to go back to where I was. Without His help, I would not have been able to do this exposition. I never would have had the boldness to have a radio broadcast, teach the gospel, or to write this book.

It is important for us to do what Jesus commanded us in St. Matthew 11:29 "...***Take my yoke upon you and learn of Me...***" He has given this responsibility to every believer. *How can we grow in faith if we don't know the basics?* The mystery of God's plan remains a mystery to those who choose to remain in darkness. They will hear, but they won't understand. They will see, but they will be blind to the truth of the message because their hearts will have become dull.

I invite you to study the book of Romans until you understand what the Christian faith is. It will impact your life. It is not to be taken at the exclusion of the rest of the Bible. It simply brings together what was taught by God's commandments, the Old Testament prophets and Jesus into one book. It is the Word of God and it disciplines us for a life of holiness. It moves us from being pew riders or just church goers to being full of faith in the Lord Jesus Christ, making us more effective witnesses for Him. We become true disciples. Let us seek the kingdom of God and His righteousness, and teach others to do the same until we experience revival in our country again.

If you do your study with a group, I suggest that you use the group discussions included or some of your own to explore and analyze the scripture. It gives you the opportunity to share your incite, experiences, and testimonies with each other. Memorize key verses that you need to hold in your heart and that speak life into your soul.

Rules to follow for all group discussions:

- Always pray before you begin.
- Be kind and considerate. Remember that it is by loving kindness that we are drawn to Christ.

- Respect each other's comments. We learn from each other.
- Remember that everyone is there to be enlightened and grow. If you don't agree with someone else, leave your disagreement to prayer and guidance from the Holy Spirit. Each man must be persuaded in his own heart and mind the truth. Don't doubt the power of the Holy Ghost to do His job.

ROMANS 1

PAUL'S MISSION

Points Covered:

- *This letter's purpose is to reveal what was a mystery*
- *Justification by faith in Jesus Christ*
- *Faith is the key element to justification*
- *The preaching of Jesus Christ*
- *Apostasy*

The Apostle Paul is the author of this epistle (letter). He concludes the epistle of Romans with this statement in chapter 16 and verse 25 Dake KJV, "***Now to him that is of power to stablish you according to my gospel, and the preaching of Jesus Christ, according to the revelation of the mystery, which was kept secret since the world began***." I believe that Paul's epistle to the church in Rome was like a master piece. I believe that he marveled at the revelation of the gospel to him by the Holy Spirit and thus he referred to it as "*the revelation of the mystery*". Acts 9:15 reveals that Paul was indeed the Lord's chosen vessel. During the writing of this letter, he was learning and teaching what God was revealing to Him by way of the Holy Spirit, the plan of salvation for all mankind. He learned that unredeemed man is a sinner by nature and cannot be saved by being what we call a "good person" or another way of saying it is "man cannot be saved by works." Paul shows that every man is a sinner and remains one until he has accepted the atonement of Jesus. It is a divine process that takes us from being victims to being victors.

During this study, I used different Bibles. My primary study Bible was the Dake Annotated Reference Bible, the King James Version (KJV). You will notice that from time to time I cite scriptures from the New King James Version (NKJV), New Century Version (NCV) and the Good News Catholic Bible (GNCV) when I felt I needed to for more clarity.

It also enables you to compare your Bible with other translations. Translations are helpful, but most importantly ask the Holy Spirit to illuminate the scriptures for you and He will.

Romans 1:1-16 *The Dake Annotated Ref. KJV*

Start your study by reading Romans 1:1-16. The author introduced himself, greeted the Roman saints, prayed for an opportunity to visit with them in the near future, and revealed to them the burden that he has for them and who it is that placed this burden upon him. It reads accordingly,

1-Paul, a servant of Jesus Christ, called to be an apostle, separated unto the gospel of God. You will find the story of Paul whose name was Saul at the time and his conversion experience in Acts 9 through Chapter 16. *2- (Which he had promised afore by his prophets in the Holy Scriptures.)* The Law, the prophets of the Old Testament and the Psalms all predicted that which was to come. *3-Concerning his Son Jesus Christ our Lord, which was made of the seed of David according to the flesh; 4-And declared to be the Son of God with power, according to the spirit of holiness, by the resurrection from the dead:* The time had come for the gospel to be understood. This gospel is concerning the one that the prophets spoke about and the Laws pointed to, Jesus Christ our Lord the Messiah. He is the subject of our faith. He came through the lineage of David and is now revealed. He has been declared to be the Son of God, by the Holy Spirit and His resurrection from the dead. He is a part of the Holy Trinity equal in power with His Father and the Holy Ghost. It is a fulfillment of the promise that God made with David that his kingdom has been established forever. *5-By whom we have received grace and apostleship, for obedience to the faith among all nations, for his name: 6-Among whom are ye also the called of Jesus Christ:* Through Him and the sacrifice that He made, we receive unmerited favor and our assignment as apostles. This gospel is for all nations of the earth who will believe and walk in obedience to the faith and His name. This was in fulfillment of the promise God made to Abraham that through him all nations of the earth would be blessed.

7-To all that be in Rome, beloved of God, called to be saints: Grace to you and peace from God our Father, and the Lord Jesus Christ. 8-First, I thank my God through Jesus Christ for you all, that your faith is spoken of throughout the whole world. 9-For God is my witness, whom I serve with my spirit in the gospel of his Son, that without ceasing I make mention of you always in my prayers; In other words, *"Greetings to the saints in Rome: may God bless you*

with His grace and peace. I thank God that I'm hearing good things about your faithfulness everywhere. With God as my witness, I serve Him with my whole heart and mind preaching the gospel of Jesus." It is important to note here that Paul was not serving God with just his intellect. Christians who serve with only their intellect often get tired and quit, because they lack the tenacity for the job. Because they lack a sense of passion for their work and compassion for people they lose the drive required. John 4:24 says "**God is a spirit, and those who worship Him must worship Him in spirit and truth**." Once you get acquainted with Paul, you will find that he had a drive and a passion for the work of the Lord that was unstoppable. The same tenacity he had when he was persecuting Christians, he had even more for the gospel. That is why he was able to write half of the New Testament and become a martyr for the sake of the gospel.

Romans 1:10-12 continues *...**Making request, if by any means now at length I might have a prosperous journey by the will of God to come unto you. 11-For I long to see you, that I may impart unto you some spiritual gift, to the end ye may be established; 12-That is, that I may be comforted together with you by the mutual faith both of you and me.*** Having heard about the faithfulness of the saints in Rome, Paul has a burning desire to come and impart to them spiritual gifts so that they could be established. To be established is to be set or fixed. To be set they needed to be fully equipped with spiritual gifts – the word of knowledge, word of wisdom, discerning of spirits, prophecy, tongues, interpretation of tongues. These gifts could be imparted by the laying on of hands. They would be established as individuals and as the body of Christ, the church. Gifts are for the edifying or building up of the church. We can be comforted together by mutual faith knowing that we are fully equipped.

13-Now I would not have you ignorant, brethren, that oftentimes I purposed to come unto you, (but was hindered,) that I might have some fruit among you also, even as among other Gentiles. 14-I am debtor both to the Greeks, and to the Barbarians; both to the wise, and to the unwise. 15-So, as much as in me is, I am ready to preach the gospel to you that are at Rome also. 16-For I am not ashamed of the gospel of Christ: for it is the power of God unto salvation to everyone that believeth; to the Jew first, and also to the Greek. I want you to know that many times I have planned to come and see you so that I might have some fruit among you just as I have among other Gentiles. I have a burden for both the Greeks and those that speak another language. (*The Greeks called people who spoke a different language Barbarians so this is how Paul used the term. He was not calling them uncivilized.*) I have a burden for those that are learned and the unlearned. As much of the gospel God has given me to preach, I am ready to preach to you in Rome. I am not ashamed of the gospel of Christ

because it is the power of God for salvation to everyone that believes. He came first to the Jew, but also for the non-Jews. One thing to note here is that the Holy Spirit gives you courage and boldness. You can see this in Paul's proclamation that "I'm not ashamed…" I interpret from that also, "*I'm not afraid…*" Why? Because the power of God is in the gospel and he knew this first-handed because it saved Him and he witnessed the salvation of others who believed. Paul was on fire for the spreading of the gospel.

ROMANS 1

Justification by Faith

Romans 1:17-23 *The Dake KJV*

17-For therein is the righteousness of God revealed from faith to faith: as it is written, the just shall live by faith. Faith is being sure of the things we hope for and knowing that something is real even if we do not see it. We were not there when God raised His Son from the dead, but by faith, we can believe, receive it and are saved. God has given every man a measure of faith. With that faith, he has access to the Father, but then he must continue to live by faith. He is enlightened and his faith in God grows as he exercises his faith from situation to situation. God's righteousness is revealed in our lives from faith to faith. "*We walk by faith and not by sight.*" (II Corinthians 5:7)

Before Paul began to teach justification by faith, he was inspired to address some things that obviously needed to be dealt with first. (*See Acts 15:19-20*) He did not want the Roman converts to be ignorant of God and the New Covenant. He was acquainted with the Gentiles background of idolatry and the Jews Judaistic background so he could deal with both. He begins, *18-For the wrath of God is revealed from heaven against all ungodliness and unrighteousness of men, who hold the truth in unrighteousness;* Evil and wrong doing are not part of His character. There are those who know the truth but hinder the teaching of it so that their own agendas are promoted. When men know the truth but suppress it to satisfy the lust of their flesh, it displeases God. Many times God punished Israel because of their disobedience.

In Romans 1:19-23, Paul dealt with some specific things that anger God and cause apostasy. **Apostasy** *means falling away or deserting the faith.* It reads, *19-Because that which may be known of God is manifest in them; for God hath shewed it unto them. 20-For the invisible things of him from the creation of the world are clearly seen, being understood by*

the things that are made, even his eternal power and Godhead; so that they are without excuse: It is clear from our existence to everything around us that there is a supreme power. We can't name one man that can create a real sun, moon, man, bird, etc. We can't see the wind, but we can feel it. We can see the stars and learned the design of the solar system. It is evident that someone keeps them organized and in motion. Have you ever seen the birth of a new born baby? It is clear by these very things that an eternal power and Godhead really exist.

21-Because that, when they knew God, they glorified him not as God, neither were thankful; but became vain in their imaginations and their foolish heart was darkened. 22-Professing themselves to be wise, they became fools. 23-And changed the glory of the uncorruptible God into an image made like to corruptible man, and to birds, and four-footed beasts, and creeping things. It is unfortunate that man disregards the eternal power and Godhead, because it puts them on a path that leads them to destruction. In past times when man didn't honor God and weren't grateful to Him, they did everything that came to their imaginations and their hearts were filled with darkness and corruption. Instead of searching for Godly wisdom, they looked for signs from their horoscopes, messages from the occult through wedgies boards and palm reading, etc. While they considered themselves wise, they were really fools. They made images with their own hands, worshipped them, feared them, and bowed down before them. *Have you made anything with your own hands that have more power than you?* All these idols did was corrupt them even more.

These are things that lead to apostasy, which is a progressive thing. One thing leads to another, sometimes to the point of no return. Paul teaches in his epistle that it is by doing these things that you will fall away from the faith and lose fellowship with God:

1) Knowing God, but not glorifying Him
2) Having an ungrateful attitude
3) Being vain in your imaginations
4) Having darkened hearts
5) Thinking you're smarter than God
6) Following your own ideas and becoming fools
7) Man worshipping images he has created
8) Lusting in the heart
9) Twisting the truth of God's Word to a lie
10) Worshiping and serving the created instead of the Creator

If you've studied Israel's history in the Old Testament, you will recall that they always got into trouble with God whenever they fell into idol worship. Paul warns the saints not to let this be a stumbling block to them getting to know and experience a relationship with Christ Jesus.

Romans 1:24-27 *NCV*

"24Because they did these things, God left them and let them go their sinful way, wanting only to do evil. As a result, they became full of sexual sin, using their bodies wrongly with each other. 25They traded the truth of God for a lie. They worshiped and served what had been created instead of the God who created those things, who should be praised forever. Amen. 26Because people did those things, God left them and let them do the shameful things they wanted to do. Women stopped having natural sex and started having sex with other women. 27In the same way, men stopped having natural sex and began wanting each other. Men did shameful things with other men, and in their bodies they received the punishment for those wrongs." Paul is telling the saints what happened to men in the past that they might not make the same mistakes. When man continuously rebel and dishonor God, He leaves them alone to do things their way. Instead of being set free from their wickedness, their bodies became full of sexual sin and they began to use their bodies in the wrong way. They twisted the Word of God to make themselves comfortable in the lust of their flesh. When they twisted it they were deceiving or lying to themselves. They worshiped the things that God created instead of the Creator. This set them on a path that was destructive. People became full of unnatural sexual sins. Women no longer wanted the affection of men. Men stopped desiring the affection of women and started wanting each other. The things that men did brought shame to them and they received punishment in their bodies for what they did.

Group Discussion

Discuss the relevance of Romans 1:24-27 to what is happening today?

Romans 1:28-32 *NKJV*

"28And even as they did not like to retain God in their knowledge, God gave them over to a debased mind, to do those things which are not fitting; 29being filled with all unrighteousness, sexual immorality, wickedness, covetousness, maliciousness; full of envy, murder, strife, deceit, evil-mindedness; they are whisperers. 30backbitters, haters of God, violent, proud, boasters, inventors of evil things, disobedient to parents, 31undiscerning, untrustworthy, unloving, unforgiving, unmerciful; 32who, knowing the righteous judgment of God, that those who practice such things are deserving of death, not only do the same but also approve of those who practice them."

The NCV Bible translators omitted the word "fornication" for whatever reason from verse 29. It is translated in the NKJV as "sexual immorality". The Apostle Paul was very bold and straight-forward when he taught the gospel given to him. Remember he said, "***I'm not ashamed of the gospel because it is the power of God unto salvation***." He didn't shade it, compromise it and that is probably why he became a martyr for the gospel. He made it clear what righteousness is and what it was not. It is crucial that men understand the gospel. In it is the power of God to salvation. When you consistently ignore righteousness and persist to do things the way you want, God will leave you alone to do whatever it is you want to do. What in essence is really happening is that you leave Him and when you leave Him you lose His shield of protection around you and you are open prey to evil forces. Remember that He cannot dwell in an unclean place. If you know the story of Job, you know that He took His hedge of protection from around Job, but this was a test for Job and proof to Satan that Job was His servant.

God is our Creator. He is our divine parent, our Father. "*Father knows best.*" He knows every path, crooked and straight and He knows what lies ahead. He gave us instructions on what paths to take and which ones not to take. For instance, it is like a parent telling their child, "*Don't climb that tree, because you may fall and hurt yourself.*" Let's say the child climbs the tree, falls and break a leg. The parent didn't break the child's leg. They simply told the child not to climb the tree because they knew it wasn't safe. So, when we disregard God's instructions, as the child did in the scenario, we bring some things on ourselves. We blame God for a lot of things that happen to us that are really our fault.

Some Christians, unfortunately, think that it is not important to have a true knowledge of God, that this is something only the preacher should have. Instead of seeking to know God for themselves, they follow, "*They say*". This is not to say that you can't trust in what the preacher is saying, but you must study so that you will know false doctrine when

you hear it. There are wolves in sheep clothing, false teachers and preachers. How can you identify them if you don't know the Word of God? This is why we must take the responsibility to study.

In verse 28, the Apostle Paul said, God left them and allowed them to have their own worthless thinking and to do the things they wanted to do. Because of this, they are filled with evil, selfishness, and hatred. They are full of jealousy, murder, fighting, gossiping, lying, and thinking the worst about each other. He said "They hate God. You may ask, "*How did he know they hated God.*" Jesus said in John 14:15, "***If you love me, you will keep my commandments***." One cannot love God and disobey Him. Luke 16:13 says, "***No servant can serve two masters; for either he will hate the one and love the other, or else he will be devoted to one and despise the other…***"

When men fall away, they become filled with all kinds of unrighteousness. They boast about themselves. They are rude and conceited. They invent ways to do evil. Children do not obey their parents. People become foolish. You can't trust them to keep their promises. They don't show kindness or mercy to others because they are mean-spirited. They know God's judgment about these things. "***For the wages of sin is death, but the free gift of God is eternal life in Christ Jesus our Lord,***" but they continue to do evil things and even applaud others who do them. *(Romans 6:23)*

We can have the eternal life that is promised to us if we will seek to know Him and have an intimate relationship with Him. If you are having a problem with sexual immorality, then that is your challenge. "***Seek the Lord while He may be found; call upon His name while He is near:***" *(Isaiah 55:6)* God is still setting captives free. All you have to do is believe and trust in Him. Without faith it is impossible to please God. Without faith, we cannot conqueror sinful flesh and have the abundant life rich with the blessings that He promised to us.

God has not changed his mind about sexual immorality. He outlined them all in Leviticus 20. Because of His grace and mercy, the punishment is different here on earth. For example, no one is stoned to death because of adultery. Because of the continuous covering of the blood that Jesus shed for us on Calvary, we can come to Him on our own and ask for His forgiveness. He is the authority and judge for sins such as adultery, incest, bestiality and homosexuality which are expressed in Leviticus and other parts of the Bible. That same authority is revealed in the New Testament. Women's liberation gave women a relaxed attitude about their own sexuality. If you've watched any of the notable talk shows, you'll see women revealing unashamedly to the whole world their sexual behaviors. They talk about sleeping around, having multiple partners, cheating, partner switching, etc. Many talk shows and movies are corrupt because they encourage fornication, promiscuity, and other behaviors that are unbecoming to Christians. What was sexual immorality in the Bible

times still is today. God's position on these things has not changed. *"For I am the Lord, I change not…"* (Malachi 3:6)

Today's Relevance

There is so much going on in our society today that substantiates the importance and relevance of what Paul is teaching here. Same sex relationships are at the forefront of issues today; legalizing gay marriage, gay people adopting children, etc. God established the order of things on the earth that He created. He created relationships. In Genesis 1:27-28 NCV, *"So God created human beings in his image. In the image of God he created them. He created them male and female. 28-God blessed them and said, "Have many children and grow in number. Fill the earth and be its master. Rule over the fish in the sea and over the birds in the sky and over every living thing that moves on the earth."* God created two sexes, male and female. In Genesis 2:18 God created the woman to be her husband's help mate and it was established in Genesis 1:28 that they should be fruitful or have children and multiply the earth (grow the population of the earth). God established further that the man would leave his father and mother and cling or unite to his wife as though they are one flesh. God then made mankind ruler over every living animal that fly, crawl, swim and move about the earth. These were relationships that He created.

With Gay liberation or coming out of the closet have come a host of other situations. Men, who are husbands and fathers, prowl beaches and rest areas searching for other men to have sex with, oftentimes total strangers. Pedophiles invade the Internet searching for children they can violate. These pedophiles aren't your neighborhood scum. They are men of reputation, with good jobs who will risk everything they have for a sexual fantasy. *"God left them to do the shameful things they wanted to do." (Romans 1:26) "…men did shameful things with other men, and in their bodies they received the punishment for those wrongs." (Romans 1:27)* Is this the kind of shame that the Bible speaks of. Is it possible that HIV and AIDS, and the multitude of STDs be the punishment for those wrongs?

For more on the behavior and medical consequences of same sex relationships visit this website: http://www.familyresearchinst.org/FRI_EduPamphlet3.html. The information in the report is done by Dr. Paul Cameron, Ph.D., Chairman of the Family Research Institute of Colorado Springs, Colorado. The purpose of this information is not to hurt people in same-sex relationships, but that they might know the truth. The proof, as they say, is in the pudding. God loves all mankind and He sacrificed His only son so that we could be set free from the bondage of sin. We must demonstrate the same love that Christ demonstrated. We must avoid being homophobic and love people, but not necessarily their behavior. Because

we love them, we must continue to preach and teach the gospel of Jesus Christ that we may see them set free and saved. There is power in the Word of God. It is the only thing that will set us free from our sins. The one important thing to remember above everything else is one can be set free and many have through the Lord Jesus Christ. When He sets you free you are indeed free. In the same way that we protect our children from other influences, we do the same in the best way that we can, but without ridiculing, hatred, and malice. Train them up in the ways of righteousness.

God dealt with a host of things in his epistle to the Romans. The purpose intended was that men live their lives as VICTORS not victims. There is nothing too hard for the Lord.

As the Apostle Paul cautioned the Romans, the same message is left for us today and future generations. God's Word will stand and not return void. We must make sure that we are teaching the gospel without compromising it. We must encouraged people to seek repentance and know that there is no problem too big for God to solve. We must encourage people to seek to have a meaningful personal relationship with Jesus. In our witnessing we must remember that it was through loving kindness that we were drawn. We must allow our witnessing to be without compromise, but in truth and in love.

In order to walk this walk of faith, there will be times when you will have to dare to be different. You will feel awkward and perhaps alone. Just remember it is dangerous to be "a bird of a feather." It is better to feel awkward and be safe in the loving arms of Jesus. We must never fail to glorify God, giving the Creator honor and glory, giving him the praise. As is evidenced today in our society, many have become vain in their imaginations, conceited and have an excessively high regard for what others think of them. They care more about their reputation among men than they do with God. God knows our hearts. We can't fool Him. We may fool ourselves and others, but we can't fool Him. If we become enlightened, our lives will reflect it, or if our hearts have become darkened, our lives will reflect it.

The letter to the Romans addressed idolatry, the images of men and four-footed beast, etc. It is important that we not think that this reflects back solely to the Gentiles of that day. A definition of idolatry is *excessive devotion to or reverence for some person or thing*. Sometimes your idol is not something that you created, such as a statue of a bird or crocodile, but the things that we devote ourselves to more than we do God. Many thank God for blessing them with certain things, like their jobs, etc., but then give more devotion to that thing than they do to Him. They'll work long hours or sit for hours entertaining themselves in front of the television, but complain if worship on Sunday goes beyond a certain hour. You won't do this when you fall in love with Jesus, but you can't fall in love with Him until you learn to worship and honor Him for being the best thing that ever happened to you. To fall

in love with Him you must spend time in fellowship with the creator, glorifying His name and thanking Him for all that He has created and done for you.

The Word of God as given to God's chosen vessel Paul is just as applicable to our lives today as it was then. Let us not make the mistake of interpreting the Word of God the way we want, changing His truth into a lie to satisfy the lust of our flesh. Let us not be foolish to think that we can pass laws that will change God's righteousness by declaring something legal or voting to pass a bill that will sanction something contrary to God's righteousness. Regardless of what our government sanctions as correct, the Word of God takes precedence. Christians must do as the song says, "*Walk in the light, the beautiful light; go where the dew drops of mercy shine bright. They shine all around us by day and by night, Jesus the light of the world.*"

Quiz -- Romans 1

Match the following words with their definition.

_____Apostle a. The good news of Jesus Christ

_____Grace b. Falling away from or deserting the faith

_____Gospel c. Unmerited favor (favor you don't deserve)

_____Apostasy d. A sinner

_____Unredeemed man e. One sent with the full power of attorney to act on behalf of another.

Select the best answer.

1. Who is the subject of Paul's epistle to the Romans?
 a. John the Baptist
 b. Jesus Christ our Lord
 c. Sinners in rebellion
 d. The Pharisees and Sadducees

2. God has given every man a measure of _____.
 e. Joy
 f. Peace
 g. Faith
 h. Testing

3. We are justified or pardoned by _____.
 i. Obeying the Word
 j. Loving everybody
 k. Faith in Jesus Christ
 l. The work that we do for Christ

4. When men fall away from God, they do which of the following:
 m. become filled with all kinds of unrighteousness
 n. boast about themselves

 o. walk in faith

 p. both *a* and *b*

5. **True** or **False**. When men are persistently disobedient, God never gets angry with them and withdraw Himself from them.

6. Finish verse 28. And even as they did not like to retain God in their knowledge, God gave them over to _____, to do those things which are not fitting;

 a. The enemy

 b. Drunkenness

 c. Debased minds

 d. ridicule

7. **True** or **False**. Without faith it is impossible to please God.

ROMANS 2

GOD IS NOT A RESPECTER OF PERSONS

Points Covered

- *God's judgment is righteous*
- *God is not a respecter of persons.*
- *Not the hearers of the law are just in the sight of God, but the doers of the law are justified.*
- *God will judge the secrets of men.*

When we study Chapter two of Paul's epistle, we learn that it is not what we do that saves us. Going to church and going through the motions of ceremonies is not what saves us. A lot of people go to church. It is good that they go, because in due time they can become enlightened. The church is a group of baptized believers, the established body of Christ. The church will stand and the gates of hell will not prevail against it. We must be penitent Christians seeking to find mercy that we may find grace in our time of need. It does not benefit us to hear the gospel preached Sunday after Sunday and not apply it to our lives. We fool ourselves when we think that we are doing the Pastor or someone else a favor by showing up. We will be judged by the very gospel that we hear from the pulpit. We have not received the gospel until we've applied it to our life. I used to hear my mother say, "*You can take a horse to the water, but you can't make him drink.*" We can hear the gospel preached at Church, by radio, television, etc., and we can say "Amen", however hearing it and agreeing with it is not enough. It is our duty to apply it to our lives. We have the same choice that Adam and Eve had, to obey or to disobey God's commands. No one else can do that for us, because we are each accountable for ourselves. The important thing to know is when Christ rules in your heart, you are led by the Spirit, not by a set of rules. I'm reminded of a song we sing that says "*When the Spirit speaks to me; with my whole heart I'll agree, and my answer will be "yes, Lord, yes.*" The Apostle Paul said in his letter to the Philippians, (Philippians

2:12), "*Therefore, my beloved, as you have always obeyed, not as in my presence only, but now much more in my absence, work out your own salvation with fear and trembling.*" This is not a chore to those who are earnestly seeking to know God.

We are living in a day and age when so many things are being validated by the passing of laws that are contrary to God's instructions and because of that they are being accepted by society. It is important that we study the scriptures and know for ourselves what God's plan of salvation is. Holding someone else to blame or accountable for our wrong doing is not an escape. We are each accountable for ourselves.

The Apostle in this chapter deals with hypocrisy, ungodliness, how God will judge it, and what true circumcision is. He did not walk with Christ as the other apostles did, but Christ chose Him as a vessel and imparted to him the plan of salvation. Jesus taught men not to judge one another, in St. Matthew 7:1-2 He says, "*Judge not that you be not judged. ²For with what judgment you judge, you will be judged; and with the measure you use, it will be measured back to you.*"

Romans 2:1-3 *NKJV* -- *Regarding Judging One Another.*

"*Therefore you are inexcusable, O man, whoever you are that judge: for in whatever you judge another you condemn yourself; for you that judge practice the same things. But we are sure that the judgment of God is according to truth against them which commit such things. ³And do you think this, O man, you who judge those practicing such things, and doing the same, that you shall escape the judgment of God?*" We can't hide anything from God. He knew the Jews were doing wrong behind closed doors and then judging others for the same sins they were guilty of. Paul tells them, "You are not *excused from judging others. When you condemn them, you are condemning yourselves as well. God's judgment is according to truth, and against the ones that do these things. Do you think that you will escape the judgment of God?*" This lesson speaks to us today in the same way. Are you judging and condemning others? Stop and examine yourself? You might be surprised. You may be guilty yourself of the same thing. Your situation may not be as destitute as the other person's, but you can be guilty of the same thing. If you are guilty, you are condemning yourself when you condemn them. With the same measuring stick or measure that we use to judge others, we will be judged. Do you remember the fall of Rev. Jim Baker and PTL in 1987? It was revealed and leaked to the media that he had an affair with Jessica Hahn who was bribing the ministry for $279,000 to keep silent about the affair. During this period of time, you could hear the condemnation of Jim Baker by others all over the television. One preacher, in particular, who condemned

Jim Baker was Rev. Jimmy Swaggart. It wasn't much longer before a similar condemnation came upon Rev. Swaggart and he, too, fell from his throne. Oh, how he could've use some mercy then. "***Blessed are the merciful, for they shall obtain mercy.***" (St. Matthew 5:7) This is why we should, instead of judging others, spend our time praying for one another. I want you to know that while we may consider ourselves intelligent, law-abiding citizens, with titles and status in our community, it is not by those things that we will be judged as righteous, but by the truth of God's righteousness. If you are doing wrong behind closed doors, your status does not make you right. God has been merciful to Rev. Baker and Rev. Swaggart for they both have found their way back to the light. God is good.

Romans 2:4-5 *Dake KJV*

"***⁴Or do you despise the riches of his goodness and forbearance, and longsuffering; not knowing that the goodness of God leads you to repentance? ⁵But after thy hardness and impenitent heart treasurest up unto thyself wrath against the day of wrath and revelation of the righteous judgment of God; ⁶Who will render to every man according to his deeds:***" In other words, "*Can't you see how good God has been to you? Are you so blind that you can't see the riches of God's goodness, his tolerance, and his patience? If you see that, how can you despise His goodness and His mercy?* God is patient with us and refrains from bringing judgment upon men. It is that goodness that leads them to repentance. Hearts that are hard and can't be penetrated are storing up wrath for themselves for the Day of Judgment. That day will reveal to mankind that the judgment of God is real and every man will be rewarded or punished according to his deeds.

Romans 2:7-11 *NKJV*

7-Eternal life to those who by patient continuance in doing good seek for glory; honor, and immortality; 8-but to those who are self-seeking and do not obey the truth, but obey unrighteousness—indignation and wrath, 9-tribulation and anguish, on every soul of man who does evil, of the Jew first and also the Greek; 10-but glory, honor, and peace to everyone who works what is good, to the Jew first and also to the Greek. 11-For there is no partiality with God.

In verses 7-11, Paul explains God's just judgment. As we look around our world today we can see endless crimes, injustices, and evil that appears will go on forever. It would be

foolish of us to think that Jesus is too near-sighted to see these things. The day will come when He will come and that He will judge each and everyone of us by our deeds. So don't gamble away your opportunity for eternal life. Don't put off what you can do today for tomorrow. Life for some will be suddenly snatched away. Are you prepared?

To those who are patient and continue in well doing, keep seeking for glory, honor, immortality, and eternal life. To you that are contentious (quarreling), and don't obey the truth, but instead obey *un*righteousness, and are full of anger and wrath, your reward is misery and anguish. God's judgment is equal, to the Jew first and then the non-Jew. People, whose works are good, will be rewarded glory, honor, and peace, to the Jew first and to the non-Jew for God is not a respecter of persons.

Romans 2:12-16 *NKJV*

Verses 12 through 16 reveals that God will judge our character and conduct, and judge us on the basis of light received. This is how it reads, *"¹²For as many as have sinned without law will also perish without law, and as many as have sinned in the law will be judged by the law; ¹³ (for not the hearers of the law are just in the sight of God, but the doers of the law will be justified; ¹⁴For when Gentiles, who do not have the law, by nature do the things in the law, these, although not having the law, are a law to themselves, ¹⁵Who show the work of the law written in their hearts, their conscience also bearing witness, and their thoughts the mean while accusing or else excusing them) ¹⁶in the day when God will judge the secrets of men by Jesus Christ according to my gospel."* Paul is saying here that God will judge us all the same. He will judge people who did not have the Law of Moses. Though man inherited the sinful nature of Adam, man inherited something else, conscience. He now knew what was good and what was evil. There was no Mosaic Law when Cain killed his brother Abel, but he knew that what he did was wrong. He was not excused for the wrong he did. Whoever sinned without the law will die and whoever sinned with the law will be judged by it. If they are sinners, they will be lost, even though they did not have the law. And, in the same way, those who have the law and are sinners will be judged by the law for it is not enough to be a hearer of the law; you must be a doer of the law to be justified.

When the Gentiles by nature followed the conscience and bore witness even though they had no written law. Paul says they were a law to themselves, because the unwritten law was upon their heart. Their thoughts are the way in which they accuse or excuse themselves. They are enlightened in their hearts and their consciences witness to them what is wrong and what is right. God will judge the secret thoughts of all men through Jesus Christ,

according to the foundations of the gospel Paul is teaching. He will judge man based on his **deeds and light received**, not on the knowledge and laws that we have heard, perhaps even memorized, but never kept.

Romans 2:17-21 *NKJV*

In Romans 2:17-21, Paul openly dealt with the Jew using his superior knowledge, privileges, and calling which only served to condemn him more than the Gentiles who obeyed the law by nature. Verses 17-21 he says, "***Indeed you are called a Jew, and rest on the law and make boast in God, 18and know His will, and approve the things that are excellent, being instructed out of the law; 19And are confident that you yourself are a guide to the blind, a light of them which are in darkness, 20an instructor of the foolish, a teacher of babes, having the form of knowledge and truth in the law. 21You, therefore who teach another, do you not teach yourself?***" The Jews were deceiving themselves in thinking that the family they were born in, their knowledge, and being God's chosen people made them superior and gave them the authority to condemn others. They knew the law. They knew God's will and approved its excellence, but their confidence was in themselves and they were like the blind leading the blind. They were being hypocrites, telling others not to steal and were stealing themselves. They were telling others not to commit adultery and were committing it themselves. They said that they hated idols, but they were dishonoring God by using consecrated things for themselves and robbing the temples. They were trying to teach others what they should have been teaching themselves.

Romans 2:25-29 NKJV

In the Old Testament, circumcision was an action that served as a sign of God's covenant with His people. Jehovah was the God of Abraham and His descendants, and they belonged to Him, and were to worship and obey Him only. Moses and the prophets often reminded them that the outward rite, to have any significance, must be accompanied by a "circumcision of the heart." In verses 25-29 the Apostle deals with this same issue. It reads, "***For circumcision is indeed profitable, if you keep the law: but if you be a breaker of the law, your circumcision has become un-circumcision. 26Therefore if an uncircumcised man keeps the righteous requirements of the law, will not his un-circumcision be counted for circumcision? 27And will not the physically uncircumcised, if he fulfills the law, judge you who, even with***

your written code and circumcision, is a transgressor of the law? ²⁸For he is not a Jew who is one outwardly, nor is circumcision that which is outward in the flesh; ²⁹but he is a Jew who is one inwardly; and circumcision is that of the heart, in the Spirit, not in the letter; whose praise is not from men, but from God.'' The Apostle is teaching the same thing that Moses and the other prophets taught. Circumcision has no value if you are breaking the Law of Moses. He compares them to those who had **not** been circumcised in the flesh, but were keeping God's commandments and he tells them, they are able to judge you. Being circumcised outwardly does not make you a Jew, but you are a Jew only if you are one inwardly, having real circumcision in the heart. A circumcised heart is humble before God and repentant when you know you are guilty. You are not rebellious, but follow God's commandments willingly. If you break the law and your circumcision becomes un–circumcision, shouldn't one who has not been circumcised in the flesh, but kept the law be counted as circumcised? He fulfills the law and can judge you who transgress the law?

Today's Relevance

Just as the Jews had to realize that being who they are (God's chosen people), does not exempt them from having a heart that is pure. Christians today must realize that joining the Church and going through outward expressions does not make one a Christian, no matter what our title or position is in the Church or community. We can wear the label *"Christian,"* but it is null and void if in our hearts we have not received the gospel. A real Christian is humble in spirit and seeks to have a pure heart before God. He recognizes that he is a sinner save by the grace of the Lord and Savior, Jesus Christ. He recognizes that it is Christ alone that justifies or pardons our sin. Outward expressions become vain, just as circumcision of the flesh does when there is no sincerity of the spirit and truth in the heart. Real circumcision is of the heart and Spirit and tells us when we are right and when we are wrong. It will draw us to repentance when we know that we are guilty. It is not enough to be hearers of the Word. We must be doers in order to be justified. God is not a respecter or persons, and He will judge every man according to his deeds.

Quiz – Romans 2

Choose the best answer or answer True or False in the exercise below.

1. Circumcision of the heart means:
 a. Being faithful and true to each other
 b. Being fun-loving and king
 c. Being humble before God and repentant
 d. Being yourself

2. How does Paul define who a real Jew is?
 a. A real Jew is one who has a circumcised heart.
 b. A real Jew is one born into a Christian family
 c. A real Jew is one who is one inwardly
 d. Both a and c

3. The Apostle Paul cautioned people about judging one another. Why is it important not to judge others?
 a. In the same way that you judge you will be judged and condemned
 b. Only elected judges should judge others
 c. Judging causes God to be angry with you
 d. All of the above

4. **True or False**. God is not a respecter of persons. He will judge all men by their deeds and light received.

5. **True or False.** Christians today must realize that joining the Church and going through rituals and outward expressions does not make one a Christian.

6. **True or False.** Physical circumcision covered the Jews even if they were breakers of the law.

7. **True or False.** One who had not been circumcised in the flesh and followed God's commands willingly were counted as circumcised.

8. **True or False.** God will judge the secrets of men by Jesus Christ according to the gospel.

ROMANS 3

THE WHOLE WORLD IS GUILTY

Points Covered

- *The whole world is guilty.*
- *Jews and Gentiles live under the bondage of sin.*
- *Everyone must be justified by faith to be saved.*
- *God makes people right with Himself through their faith in Jesus Christ.*
- *All are made right with God by his grace.*

Paul, a Jew himself was born in Tarsus, Turkey which was under Roman rule so he had Roman citizenship. Rome was called the capital of the Gentile world. At the time of the writing of this epistle, it is determined that he was probably in Corinth. His mission took him to areas that were not evangelized and he started churches there, but he did not start the church in Rome. The burden of responsibility given to Him as a chosen vessel, however, rested upon him to teach them the gospel. The main theme of this epistle or letter is *justification by faith*. Paul was called to be an apostle to the Gentiles, but before his conversion he was a devote Judaist. If anyone understood what issues existed among the Jews and their controversy with the non-Jews, he did. In an effort to correct the erroneous thinking that existed between Jewish converts trying to make the transition from Judaism to Christianity and Gentile differences, Paul addresses them in this letter.

Romans 3:1-9 *NCV*

In Chapter three, Paul teaches who needs justification. In Romans 3:1-9, he continues his teaching with a dialogue of questions and answers to clear up erroneous thinking. This

is how the dialog went: ¹"***So, do Jews have anything that other people do not have? Is there anything special about being circumcised? ²Yes, of course, there is in every way. The most important thing is this: God trusted the Jews with his teachings. ³If some Jews were not faithful to him, will that stop God from doing what he promised? ⁴No! God will continue to be true even when every person is false. As the Scriptures says: "So you will be shown to be right when you speak, and you will win your case." ⁵When we do wrong, that shows more clearly that God is right. So can we say that God is wrong to punish us? (I am talking as people might talk.) ⁶No! If God could not punish us, he could not judge the world. ⁷A person might say, "When I lie, it really gives him glory, because my lie shows God's truth. So why am I judged a sinner?" ⁸It would be the same to say, "We should do evil so that good will come." Some people find fault with us and say we teach this, but they are wrong and deserve the punishment they will receive.***" The Jews are God's chosen people. Because of the promises He made with their fathers, nothing will change that. That is an honor bestowed upon them. However, they have to accept the New Covenant like everyone else in order to be saved. It does not become null and void because a person or groups of persons won't accept it. The New Covenant is the fulfillment of the promises that God made with the fathers and prophets. It goes back to the necessity of what took place in the Garden of Eden.

Romans 3:10-18 NCV – Sin is a Serious Problem

In verses 10-20, to make his point clear, Paul paints a picture of human nature to show that the whole world is guilty. It reads like this from the NCV: ¹⁰***As the Scriptures say: There is no one who always does what is right, not even one. ¹¹There is no one who understands. There is no one who looks to God for help. ¹²All have turned away. Together, everyone has become useless. There is no one who does anything good; there is not even one.***" ¹³***Their throats are like open graves; they use their tongues for telling lies. Their words are like snake poison.***" ¹⁴"***Their mouths are full of cursing and hate. ¹⁵They are always ready to kill people. ¹⁶Everywhere they go they cause ruin and misery. ¹⁷"They don't know how to live in peace." ¹⁸They have no fear of God.***" In this passage of scripture that Paul refers to are Psalms 14:2-3, Isaiah 59:7, and Ecclesiastes 7:20. Here's Ecclesiastes 7:20 NKJV, "***For there is not a just man on earth who does good and does not sin***." There is not one person on earth who has never sinned and does right all the time. Sin is a real force that dominates and enslaves. When God look upon the earth and searches for godly men, He sees that there is none that understands the magnitude of sin. If they did they would seek His help more

often. Instead they wander around like lost sheep and are therefore not profitable. There is not one perfect among them.

Their Throats are like an open grave, ready to be filled with dirt (gossip). Their tongues are deceitful. They tell lies without even knowing it. Their words are like the venom of a snake and its poison serves only to destroy the reputation of men. They are quick to get angry and when they get angry, it doesn't matter what comes out of their mouths or what they do to get even. Because they hate, they are capable of killing people. They ruin things and leave destruction wherever they go. Peace is foreign to them because they've grown accustomed to fighting among themselves. Because their confidence is in themselves, they don't fear God.

Today's Relevance

Is he not describing human nature today? How many of us haven't relished hot gossip? I've been guilty myself. Where can you go that you won't find gossip? If you're at home, the telephone will ring with a talebearer on the other end of it with the latest gossip. Turn on the television and you'll find a reporter anxious to be the first to break the news or pick up the newspaper and you'll find one trying to be the first to make headlines. It is not often that they will take the time to investigate the credibility of their reports. This is how they make their money. Few of them care whose lives they ruin. Such was the case of Princess Diana. Needless to say, the night of her death, they got a headline they didn't expect, one that they were much responsible for. How many of us won't pass the hot gossip on to someone else? Oftentimes the gossip we hear is false, but we pass it on anyway. When we do, all we are doing is passing on a lie which makes us guilty of lying, too. It only serves to destroy the reputation of men, but do we care. There are still those of us that will lay their religion down and put up a good fight. There are those of us that like drama so we'll keep something stirred up. These are reasons Paul cited that show ***the whole world is guilty.***

Romans 3:19-20 *NCV* – The Jews Are Not Exempt

"19–We know that the law's commands are for those who have the law. This stops all excuses and brings the whole world under God's judgment, 20–Because no one can be made right with God by following the law. The law only shows us our sin." In Romans 3:19-20, Paul makes it clear to the Jews who were given the law that they are not exempt from the need

for justification. Verses 10-18 proved it. The law, however, while it teaches us what sin is, it cannot justify or pardon us. How then can we be justified?

Romans 3:21-31 *NCV*

21-But now God's way of putting people right with himself has been revealed. It has nothing to do with law, even though the Law of Moses and the prophets gave their witness to it. 22-God puts people right through their faith in Jesus Christ. God does this to all who believe in Christ, because there is no difference at all: 23-everyone has sinned and is far away from God's saving presence. 24-But by the free gift of God's grace all are put right with him through Christ Jesus, who sets them free. 25&26-God offered him, so that by his blood he should become the means by which people's sins are forgiven through their sins, in order to demonstrate his righteousness. In this way God shows that he himself is righteous and that he puts right everyone who believes in Jesus. 27-What, then, can we boast about? Nothing! And what is the reason for this? Is it that we obey the Law? No, but that we believe. 28- For we conclude that a person is put right with God only through faith, and not by doing what the Law commands. 29-Or is God the God of the Jews only? Is he not the God of the Gentiles also? Of course he is. 30-God is one, and he will put the Jews right with himself on the basis of their faith, and will put the Gentiles right through their faith. 31-Does this mean that by this faith we do away with the Law? No, not all; instead, we uphold the Law. In Verses 21-31, Paul tells what the remedy is for world guilt. The righteousness of God without the law is shown plainly. The rites and ceremonies of the law and the predictions of the prophets all testified of the redeeming blood of Jesus Christ that would justify or pardon men apart from the law and the prophets. The righteousness of God is by **faith** in Jesus Christ to all that **believe**, whether you are Jew or non-Jew; there is no difference. All have sinned and come short of the glory of God. We are made right through God's grace (unmerited favor) which is a free gift. God was gracious to the sinner and gave his Son as a remedy. That one act that He allowed His Son to perform on the cross was enough to cover the sins of the whole world. Faith in his blood declares his righteousness for the remission of sins. This is the **atonement** that we must accept by faith. *Atonement* is the act by which God restores a relationship of harmony and unity between Himself and mankind. The atonement took away the sins of the Old Testament saints whose cleansings from meats, drinks, different washings and carnal ordinances were temporary until the time of reformation (Hebrews 9:10) and it takes away the sins of each sinner that repents.

You ask "How then can we be justified?" Justification is by **the law of faith**, not by works, and leaves no place for boasting. We therefore conclude that a man is justified by faith without the work of the law. It is the universal remedy for a world guilty of sin. There is one God. He is God of both the Jews and the Gentiles (non-Jews), men of every nation. He is the only one who will justify the circumcised by faith, and the uncircumcised through faith. *So do we then make void the law through faith?* No. It is our faith in the Lord Jesus Christ that establishes the law. It establishes the law recognizing Christ as the subject of its rites and ceremonies. Christ fulfilled it and Christ ended it, by fulfilling in men the righteousness that the law demanded but could not give.

Today's Relevance

The same issues the people had in Paul's day are the ones we have today. That is because human nature does not change, but neither does God. He is the same yesterday, today and forever. We have issues before us today that can only be resolved by faith in our Lord and Savior Jesus Christ and we have to understand that we cannot fix them in our own wisdom and power. We can't pass laws and cast ballots on what righteousness is. When Abram believed, God counted it as righteousness and that was before the Law, so the law had nothing to do with his righteousness. Let us be knowledgeable of God's righteousness and submit to it instead of trying to establish our own by passing laws and casting ballots on issues that we know ignores God's righteousness. No matter how many Einstein and Socrates we have, no matter how many geniuses we have writing books and expressing their opinions; it is not possible for the *created* to know more than his ***Creator***. Isaiah 55:6 says, "***Seek the Lord while He may be found, call upon him while he is near...***" If we believe and have faith in the atonement, He will fulfill in us the righteousness the law demanded. II Chronicles 7:14 says, "***If my people who are called by my name, will humble themselves, pray and seek my face, and turn from their wicked ways, then will I hear from heaven and forgive their sin, and heal their land.***" God is our refuge and our strength, a very present help in time of trouble. (*Psalms 46:1*) Let us remember to call upon Him who is able (**Jude 24**) ***to keep you from falling, and to present you faultless before the presence of His glory with exceeding joy.***"

Quiz -- Romans 3

Select the best answer or choose True or False in the items below.

1) We learn this about human nature
 a. All flesh has been tainted with sin because of Adam
 b. It comes short of the glory of God
 c. Is a captive to sin
 d. All of the above

2) Paul was called to be an apostle to the
 a. Wicked
 b. Egyptians
 c. Jews
 d. Gentiles

3) The Jews had to understand that they must accept this like everyone else
 a. The power of sin
 b. The New Covenant
 c. Paul as an apostle
 d. The doctrine of the Old Covenant

4) Sin is
 a. A real force that dominates and enslaves
 b. Not a real force at all
 c. A force that there is no remedy for
 d. A state of liberation

5) The atonement
 a. Took away the sins of the Old Testament Saints
 b. Is the act by which God restores a relationship of harmony and unity between Himself and mankind
 c. Is the redeeming blood of Jesus Christ
 d. All of the above

ROMANS 4

THE ATONEMENT

Points Covered

- *Justification by faith in the atonement is a divine process.*
- *God is the only one that can declare the guilty innocent.*
- *Justification is by faith not by works.*

Paul's letter to the church in Rome became the benchmark for learning Christian Principles or the ABC's of Christianity. In St. Matthew 11:29, Jesus said, "***Take my yoke upon you and learn of me...***" It is our responsibility to study to show ourselves approved of God, workmen that need not be ashamed, rightly dividing the word of truth. (*II Timothy 2:15*) We all have the responsibility of sharing the Goods News with others.

In Chapter 3 we learned that the whole world is guilty and the remedy is faith in the atonement. Paul was what they call a realist. He was a person who faced the facts and dealt with them in a practical way. He knew the reality of sin, and dealt with it in the most thought-provoking terms. In Chapter 3, Paul drew for us a true picture of the human race and warns that man is **not** inherently good, as many today think and teach. In Romans 3:10-11 he says, "***There is none righteous, no not one, there is none that understands; there is none that seeks after God...***" He shows that it is false to think that a man through a process of education can be trained to be good. The Law of Moses couldn't train man to be good. Paul makes it clear that man's nature is completely corrupted by evil and that **unredeemed man** is in bondage to sin and death. He tells them that the remedy is "Justification by Faith," the plan of salvation for mankind. Animal sacrifices and rituals were temporal things and have been replaced with the atonement, the redeeming grace of our Lord and Savior Jesus Christ. Remember, too that Paul is helping the Jewish and

Gentile converts understand that God is not a respecter of persons; that the requirement for salvation is the same for those who were under the Law of Moses and for those that were not under the Law.

Romans 4:1-6 GNB

In Chapter 4 Paul continues to explain justification by faith. It is important to note here that it is obvious that the Epistle of Romans is not a book to be studied in isolation from the rest of the Bible. To completely understand what Paul is teaching here, you have to be familiar with the lives of Abraham and David. He uses their life experiences to teach the importance of faith.

Verses 1-6 read as follows from the Good News Bible, "**What shall we say, then, of Abraham, the father of our race? What was his experience? ²If he was put right with God by the things he did, he would have something to boast about—but not in God's sight. ³The scripture says, "Abraham believed God, and because of his faith God accepted him as righteous. ⁴A person who works is paid his wages, but they are not regarded as a gift; they are something that he has earned. ⁵But the person who depends on his faith, not on his deeds, and who believes in the God who declares the guilty to be innocent, it is his faith that God takes into account in order to put him right with himself." ⁶This is what David meant when he spoke of the happiness of the person whom God accepts as righteous, apart from anything that person does;"**

So here to further enlightened the Church of Rome on justification by faith to all that believe in the atonement, Paul uses as examples Abraham, a man who was justified 430 years *before the law* and David, a man *under the law* who was justified by faith. He explains Abraham's experience from Genesis 15:6 which says, "**And he believed in the Lord and He counted it to him for righteousness.**" Paul explains if it had been by works, he would have been able to boast about it, but God wouldn't allow that. If He did, you wouldn't be able to understand grace. He uses this example: When a person that works is paid wages, this is not called a gift, but his earnings. When you work, you're earning your keep. *What about a person that hasn't done any work, is he excluded?* No. Imagine how many souls would be lost if work was required for salvation. Do you remember the thief on the cross that asked Jesus to remember him and Jesus said, "**This day you will be with Me in paradise?**" That was grace, unmerited favor. He didn't deserve it, but God gave it to him because he *believed* in Jesus, the Messiah. Any person who has faith in what God did through the atonement God will take away his sins and count him righteous. God looks at the faith of a man and makes

him right with Himself. This is a divine process. One man can't do this for another man. Let's take another example.

Take a man who has murdered someone. The law found him guilty and put him in prison so he is doing time for his crime. The man is remorseful and acknowledges that he was wrong in killing the other person and is grossly sorry for what he did. If he could go back and change what happened, he would but there is nothing he can do that will bring that person back. He repents and submits to the righteousness of God and God declares him innocent. This is a divine process. Does it mean that the person will be set free from prison? Not necessarily. But he is set free in another sense that I will come back to later. The carnal mind cannot understand this, because all it knows is what it sees and feels. The family of the victim, because they grieve their loved-one would want to see him punished. The law has found him guilty, sentenced him to 40 years, and he is serving time for his crime. The redeemed man begins to trust God in the midst of his situation. He has accepted full responsibility for his crime. But he experiences something from behind the prison walls that he never felt when he was on the outside, freedom. He experiences a peace that is beyond his own understanding. That is because it is a divine process, one that only God can perform. God gave him grace which is unmerited favor; he didn't deserve it but God gave it to him because he had faith in Him. Will God perform a miracle to set the prisoner free? Maybe He will and maybe He won't. God may test the redeemed man (the prisoner) to see if he will maintain his trust in Him regardless of his situation. Romans 4:6-7 is a summation of what David said in Psalms 32:1-2 when the Lord forgave Him, "***Blessed is he whose transgression is forgiven, whose sin is covered. Blessed is the man to whom the Lord does not impute iniquity, and in whose spirit there is no deceit.***" David felt a tremendous burden lifted from him when the Lord forgave him for his awful deeds and he rejoiced by saying, "Happy is the man whose sins are forgiven…" He witnessed to the world what God's redeeming grace felt like. David had a circumcised heart. God knows our heart. We can't fool Him. If the intent of the heart is not right, He knows. He will know if the redeemed man (the prisoner) in the example above is grateful as David was that He forgave Him.

In Romans 4:9, Paul comes back to circumcision with the question, "***Does this happiness that David spoke of belong only to those who are circumcised?***" Circumcision was a matter that Paul needed to clear up for the Jews because circumcision for some was just a fleshly ritual because they did not have true circumcision of the heart. So he says, ***No,*** and explains, Abraham was declared righteous 24 years before circumcision, so it was not his circumcision that made him righteous. His circumcision was a *sign* to show that because of his *faith* God had accepted him as righteous before he was circumcised, so then it is clear that circumcision of the flesh did not make him righteous.

Romans 4:13-16 GNB

In Romans 4:13-16 he continues his teaching of Abraham's experience. Verse 13 reads, "***When God promised Abraham and his descendants that the world would belong to him, he did so not because Abraham obeyed the law, but because he believed and was accepted as righteous by God. 14-For if what God promises is to be given to those who obey the Law, then faith means nothing and God's promise is worthless. 15-The Law brings down God's anger; but where there is no law, there is no disobeying of the law. 16-And so the promise was based on faith, in order that the promise should be guaranteed as God's free gift to all of Abraham's descendants—not just to those who obey the Law, but also to those who believe as Abraham did. For Abraham is the spiritual father of us all;***" Paul goes on to explain to them that if people could receive what God promised through the Law, then faith would have no value. There was no Law of Moses in Abraham's day so he would not have been counted as righteous if the law was a requirement. Abraham believed and was accepted as righteous by God. The law only provokes God to anger, but if there is no law, there is nothing to define disobedience. For instance, in our day, if there were no traffic laws, no speed limit, or rules to follow when driving, we could not prevent accidents. Because we have laws governing the right way to drive, it can be determine who is at fault in an accident. God's promises were based on *faith* so that they would be his *free gift* to all of Abraham's descendants—not just to those who obey the law, but also to those who believed as he did. Abraham is the spiritual father of all who believe; both the circumcised and the uncircumcised.

Romans 4:17-22 GNB

In Romans 4:17-22, Paul continues explaining justification by faith. It reads, "***As the scripture says, 'I have made you father of many nations.'" So the promise is good in the sight of God, in whom Abraham believed—the God who brings the dead to life and whose command brings into being what did not exist. Abraham believed and hoped, even when there was no reason for hoping, and so became "the father of many nations." Just as the scripture says, "Your descendants will be as many as the stars." [19]He was then almost one hundred years old; but his faith did not weaken when he thought of his body, which was already practically dead, or of the fact that Sarah could not have children. [20]His faith did not leave him, and he did not doubt God's promise; his faith filled him with power, and he gave praise to God. He was absolutely sure that God would be able to do what he had through faith, "was accepted as righteous" were not written for him alone. [21]He was absolutely sure that God would be***

able to do what he had promised. ²²That is why Abraham, through faith, "was accepted as righteous by God." He explains here that Abraham was made a father of many nations because the God in whom he believed had the **power** to resurrect from the dead and could speak the Word and things came into existence (Genesis 1:3-26). Abraham believed God for His promises. He didn't waver in his faith. When things got tough, he didn't turn back. When God promised him that he would be Father of many nations and that his descendants would be as many as the stars, he was almost a hundred years old. Even though he submitted to Sarah's request and slept with her handmaiden, he didn't weaken in his faith. He did not consider himself and Sarah too dead to bring about the promise God made. Please read the story of Abraham if you haven't, beginning with Genesis, Chapter 12. God did so many miraculous things for Abraham because He trusted Him, so much so that he exclaimed (Genesis 18:4), "**Is there anything too hard for the Lord?**" or "**Is there anything that the Lord can't do?**" Paul said that Abraham was fully persuaded that what God promised, he also could perform. Abraham's faith gave him power and he was filled with abundant praise for the "*Most High God.*" Verse 22 says, "**This is why Abraham, through faith, was accepted as righteous by God.**"

Romans 4:23-25 *NCV*

23-Those words ("God accepted Abraham's faith") were written not only for Abraham 24-but also for us. God will accept us also because we believe in the One who raised Jesus our Lord from the dead. 25-Jesus was given to die for our sins and he was raised from the dead to make us right with God. Paul goes on to explain in Verses 23-25, that all men need to know how Abraham found justification. This is why it is written in Genesis 15:6. It was not written for his sake that it was imputed to him, but so that others could see that they, too, will receive justification by faith if they believe on Him that raised Jesus our Lord from the dead. Jesus died for our sins and was resurrected for our justification.

Today's Relevance

What does this mean to us today? We, too, have the example of Abraham to follow. Paul teaches us that no man is inherently good. All of us are stained with sin and fall short of the glory of God, but there is a remedy, the atonement. Unredeemed man is a slave to sin until he accepts by faith the atonement, *the plan that God gave to satisfy our sinful nature.* Just as Abraham believed and God counted it to him as righteousness, all we have to do is

believe. It is by faith that we receive salvation because it is a free gift. It is not something that we achieve by works, otherwise men could boast and the poor man that hasn't had a chance to do any work since coming to Christ wouldn't have a chance if he dies suddenly. It is not about how often we attend Church, sing in the choir, usher, etc. It is not about the rituals, Jewish or Christian. Just as circumcision was a <u>sign</u> to show that because of Abraham's *faith* God accepted him as righteous, these symbols while they may have rich meaning, they can only point to, not take the place of Jesus Christ, the only one with the redeeming power to save us. While works can't save us from our sinful nature, let's remember that works follow faith. James 2:26 says that, "***For as the body without the spirit is dead, so faith without works is dead also***.

One of the questions Paul clarified for the Jews was, "*What advantage do we have being Jew?*" He could ask us the same question, "What advantage do we have with our positions in the church and in our community, in being a faithful member of the church, etc.? These things can't save us from our sinful nature, only faith in the atonement can. It is the plan of salvation that God gave us that can justify or pardon us from our sins.

Quiz for Romans 4

Select the best answer.

1. Paul talked about Abraham and David of the Old Testament to
 a. Show their ignorance
 b. Show their faith in God
 c. Show how they lived as kings and queens
 d. Show their lack of faith.

2. Abraham was counted as righteous because
 a. He fed the hungry
 b. He led the people
 c. He believed God
 d. He worked solely for God

3. God's promises are based on
 a. faith
 b. working
 c. praising Him
 d. kneeling down before Him

4. **True or False**. Paul used Abraham to explain the importance of faith.

5. **True or False**. Abraham did not doubt God's promise to him that he and Sarah would have an heir between them.

6. Abraham was made the Father of _____.
 a. Many nations
 b. The Chinese
 c. Sarai
 d. Lot

7. **True** or **False**. Revelation is God's free gift to man.

ROMANS 5

THE BENEFITS OF JUSTIFICATION

Points Covered

- Justification has Benefits.
- We are made God's friends again.

Romans 5:1-5 *NCV*

In Chapter 5, Paul explains the benefits of justification by faith. "*¹Since we have been made right with God by our faith, we have peace with God. This happened through our Lord Jesus Christ, ²Who through our faith has brought us into that blessing of God's grace that we now enjoy. And we are happy because of the hope we have of sharing God's glory. ³We also have joy with our troubles, because we know that troubles produce patience. ⁴And patience produces character, and character produces hope. ⁵And this hope will never disappoint us, because God has poured out his love to fill our hearts. He gave us his love through the Holy Spirit, whom God has given to us.*" These verses reveal the benefits of justification by faith in Jesus as: 1) we have *peace* through our Lord and Savior. Peace is precious. That is why David tells us in Psalms 34:14 to pursue or chase it. Do your best to capture it. In John 14:27, Jesus said, "*Peace I leave with you, my peace I give to you; not as the world gives, I give it to you….*" Jesus is the Prince of Peace. Paul, in teaching the Ephesians Christians to dress in the armor of God, in Chapter 6:15 told them to "*…have your feet shod (dressed) with the preparation of the gospel of peace.*" In other words, wherever you go be prepared to make or keep peace with men. In St. Matthew 5:9, Jesus said, "*Blessed are the peacemakers: for they shall be called the children of God.*" 2) Secondly, we have *access by faith to his grace*. Grace is the unmerited favor or something we didn't deserve. We haven't earned it and

can't because it is not something that we can work for to obtain. It is a free gift from God. 3) In His grace we are able to be **happy** because of the hope it gives us when we share the gospel of salvation with others. 4) We are able to *glory in our **troubles***. The KJV calls them tribulations. You might ask "How can anyone glory in troubles?" That is one of those mysterious benefits that we have access to. We all have troubles in our lives, but when you are saved by God's grace His grace helps you endure your troubles. Because of your faith, you are able to stand and glory in the midst of your trials, because you know they only come to make you strong. 5) **Patience** teaches us endurance. Patience enables you to wait on Him to perform his miraculous work. 6) Patience brings **experience** or spiritual maturity that teaches you that God does things in His timing not yours. You know that God will work things out for you when you trust Him. 7) You have **hope**. You learn from experience to experience and faith to faith that there is hope. 8) We are **not disappointed**. Hope will never disappoint you because God gives you two other precious gifts. 9) God pours His **love** into your heart. 10) He gave His love through the **Holy Ghost**. This is why we can love our enemy, pray for those who despitefully use us. This is why we can forgive. This is how we can love Him with all of our heart, mind and soul.

Romans 5:6–10 *NCV*

"***When we were unable to help ourselves, at the right time, Christ died for us, although we were living against God. Very few people will die to save the life of someone else. Although perhaps for a good person someone might possibly die. But God shows his great love for us in this way: Christ died for us while we were still sinners. So through Christ we will surely be saved from God's anger, because we have been made right with God by the blood of Christ's death. While we were God's enemies, he made us his friends through the death of his Son. Surely, now that we are his friends, he will save us through his Son's life.***" Here Paul writes about the divine process by which man is saved. God gave His Son to be the sacrificial offering for mankind. How many men do you know will die for someone else, especially when they are not even a friend? This is the way God showed His great love for us. This was the depth of His love. At an appointed time when man was helpless to himself, at the right time Christ died for him. We are saved from His anger. Through Him we are made very happy in God through our Lord Jesus Christ. A man is happy when he knows that he has been forgiven for his sins, that God has wiped the slate clean. Through Christ, we are no longer against Him, but now God's friends again. We are able to fellowship or have a personal relationship with Him. If Christ saved us by His death, how much more now can

he save us by His life? In John 10:10, Jesus said, *"...I am come that you might have life and have it more abundantly."*

Romans 5:12-14 *NCV*

In Romans 5:12-15, the Apostle Paul shows the contrast between Adam and Christ. *"12Sin came into the world because of what one man did, and with sin came death. This is why everyone must die—because everyone sinned. 13Sin was in the world before the law of Moses, but sin is not counted against us as breaking a command when there is no law. 14But from the time of Adam to the time of Moses, everyone had to die, even those who had not sinned by breaking a command, as Adam had. Adam was like the One who was coming in the future."* Adam, the first man, sinned. He brought sin and death into the world, upon everyone. Even though there was no law at that time and where there is no law no account is kept, death passed upon all men because of Adam's sin. From the time of Adam to the time of Moses death ruled over mankind, even over those who had not sinned as Adam did. Because he was the first man, the whole human race was in his loins so when he sinned, he didn't act as a single person, but as a whole race. Death came to Adam by personal sin, but the whole race after him inherited it. In the same way that Adam disobeyed and brought sin upon the whole world, he was *like* the One who would come in the future to save mankind.

Romans 5:15-19 *NCV*

By contrast, Paul shows that the grace of God is much greater than the offence of Adam. *15But God's free gift is not like Adam's sin. Many people died because of the sin of that one man. But the grace from God was much greater; many people received God's gift of life by the grace of the one man, Jesus Christ. 16After Adam sinned once, he was judged guilty. But the gift of God is different. God's free gift came after many sins, and it makes people right with God. 17One man sinned, and so death ruled all people because of that one man. But now those people who accept God's full grace and the great gift of being made right with him will surely have true life and rule through the one man, Jesus Christ. 18So as one sin of Adam brought the punishment of death to all people, one good act that Christ did makes all people right with God. And that brings true life for all. 19One man disobeyed God, and many became sinners. In the same way, one man obeyed God, and many will be made right."* By the *grace* of one man, people will receive God's free gift, the gift of eternal life. In the past, when

they had to sacrifice animals to cover their sins, each man had to have an unblemished animal and they had to keep repeating this, but now this is replaced by the act of one man, by the grace of one man, our Lord and Savior Jesus. His free gift covers a multitude of faults and offences. With *one bad act* or one man's offence, sin and death ruled all people. But for those that accept God's grace and the gift of being made right with Him, by one man, Jesus Christ, they shall reign in life with Him. Just as one judgment came upon all men to condemn them, by the righteousness of Jesus Christ came the free gift to all men to be pardoned if they receive it. Just as one man's disobedience made many sinners, one man's obedience is powerful enough to cover the world's sin. For those who have faith in that one man's obedience, they are justified.

Romans 5:20-21 *NCV*

²⁰The law came to make sin worse. But when sin grew worse, God's grace increased. ²¹Sin once used death to rule us, but God gave people more of his grace so that grace could rule by making people right with him. And this brings life forever through Jesus Christ our Lord." Without the law, there were no boundaries to man's behavior. The law was given to condemn the many kinds of offences and make man know what sin was. The law pointed out man's sinful nature. This made it worse. This is the way that the KJV of verse 20 read, "***Moreover the law entered, that the offence might abound. But where sin abounded, grace did much more abound***:" Where sin flourished, Gods grace flourishes that much more. There is <u>no</u> sin too great for God to pardon. If there was, then sin and death would still reign over us and God's grace through Jesus Christ would be powerless to save us. The one <u>good act</u> of Christ makes all people right with God, regardless of how many sins you have committed. His grace gives you full pardon and you are judged "*not guilty.*" When you accept God's full grace, you are put right with Him and shall rule in life through Christ.

Today's Relevance

We still have the same benefits of justification by faith today. You may hear Christians say sometimes that they had peace in the time of a storm. What they are saying is, when they were going through some adversity, some tough situation, they had an inner peace they couldn't explain. Philippians 4:7 KJV says, ***"And the peace of God, which passeth all understanding, shall keep your hearts and minds through Christ Jesus."*** It is a peace beyond human understanding, because it is the peace that only the Prince of Peace can give.

We have access by faith to God's grace. If you have salvation, you have access by faith to something the unredeemed man doesn't have. You will have patience and endurance. When you go through trials, when you go through the fire, you come forth stronger and better and you know that it was God's unlimited grace that brought you through. You will have experiences that you can happily share with the world of His glory and no matter what you go through, you can stand.

Donnie McClurkin sings a song called **Stand** and it goes like this:

> What do you do when you've done all you can
> And it seems like it's never enough?
> And what do you say when your friends turn away, and you're all alone?
> Tell me, what do you give when you've given your all,
> And seems like you can't make it through?
>
> **Chorus** – Well, you just stand
> When there's nothing left to do
> You just stand, *watch the Lord see you through*
> Yes, after you've done all you can
> You just stand.

It is good to know that when you've messed up and everything about your situation says there is *no hope*, you have a ticket that says, "Grace." There is no sin too big for grace. His grace is so deep that no sin can go below it; His grace is so wide that no sin is too big to fit into it. When you come to Him, He won't count your sins, **all** He'll do is give you grace. All you have to do to access it **is call on the name "Jesus,"** the only one who can justify you and make you right with Him. It is through His unlimited grace that you can receive all of the benefits of justification by faith.

Quiz -- Romans 5

1) **True or False**. Grace is being equally yoked with God.

2) **True or False**. Because one man's disobedience made many sinners, one man's obedience is not powerful enough to cover the world's sin.

3) **True or False**. There is no sin too big for God to pardon.

Multiple Choice: Select the best answer.

4) God gave His love through the _____ _____.
 a. Peace He left the world
 b. The experience that we get
 c. The Holy Spirit
 d. Hope that is endless

5) Christ died for us when we were still _____ of God.
 a. enemies
 b. friends
 c. Babes
 d. followers

6) _____ sinned and brought sin upon the whole world.
 a. David
 b. Saul
 c. Adam
 d. Eve

7) It is through God's unlimited grace that we can receive all of the benefits of
 a. Justification by faith in Jesus
 b. A new name in heaven
 c. A new position
 d. Great entrepreneurs

ROMANS 6

"I" HAS TO DIE

Points Covered

- In Christ we are new creatures.
- The death of Jesus Christ paid the penalty for our sin.
- His burial made it possible for the old man to die and the new man to fellowship with Him.
- His resurrection made it possible for our mortal bodies to be resurrected and reunited with our immortal soul and spirit.
- We have power over sin and death through Christ Jesus.

In Chapter 6 Paul teaches how the *death*, *burial* and *resurrection* of Jesus Christ influence the lives of those who are baptized in Him. For a long time, I didn't know the power that my baptism in Jesus Christ gave me. It is my belief that most Christians don't understand the power that they have and as a result, live in bondage to sin and death. James 4:7 tells us to "**Submit yourselves to God. Resist the devil and he will flee from you.**" The Bible also says, "**Greater is He that is in me than he that is in the world**." While Satan is powerful, he is no match for Jesus Christ.

In Romans 6 Paul describes something divine. No man can give it to you, only God. A carnal mind cannot comprehend it. This is something that is even eluding Christians. Too many quickly stop short of seeking God's revelations.

Romans 6:1-7 *NKJV*

"*¹What shall we say then? Shall we continue in sin that grace may abound? ²Certainly not! How shall we who died to sin live any longer in it? ³Or do you not know that as many of us as were baptized into Christ Jesus were baptized unto His death? ⁴Therefore we were buried with Him through baptism into death, that just as Christ was raised from the dead by the glory of the Father, even so we also should walk in newness of life. ⁵For if we have been united together in the likeness of His death, certainly we also shall be in the likeness of His resurrection, ⁶knowing this, that our old man was crucified with Him, that the body of sin might be done away with, that we should no longer be slaves of sin. ⁷For he who has died has been freed from sin.*"

What could the Apostle Paul mean by this? How can one be dead to sin if in Romans 3:10, it says, "***There is none righteous, no not one***?" Is he contradicting himself? No, he is not. The point he made in Chapter three is that there is no person, Jew or Gentile that has never sinned before and that is exempt from justification by faith in Jesus Christ and be saved. We sin by word, thought, or deed. Just being a "good person" is not the remedy for the sinful state that Adam left all mankind in. In Chapter 6, he is talked about being *dead to sin*. What is it that makes us dead to sin? When you submit to God's righteousness and are baptized in the Holy Spirit to Jesus Christ a divine process takes place in you. The Holy Spirit comes to live in you. He is the third person in the trinity, not an object or thing. From this point on, you should begin to nurture yourself in the Holy Scriptures, because the Holy Trinity works together. When you do, you will find that the sin that was ever present in your life from day to day loses its appeal to you. That is why you hear Christians say, "*The things I used to do I don't do them any more.*" They lose the desire for things they used to long for such as drugs, alcohol, stealing, sexual sins, brawling, lying, gossiping, backbiting, etc. A transformation takes place. Now that they are *dead to sin*, sin no longer rules their lives. Does this mean that they will never sin again? No. As long as we are housed in these mortal bodies, we are subject to human error, but sin cannot rule unless you let it. If you repent, God will pick you up and you can move forward and not continue repeating the same sin which make you become wicked.

Paul goes on to say when you were baptized into Jesus Christ you were baptized to his death. You were buried with Him by baptism to death and should walk in the new life you've been given. If we are planted together in the likeness of his death we shall likewise be also in the likeness of his resurrection. In other words, when you became one with Him in fellowship, you no longer have the nature of the first man Adam, but of the second man, Christ. We benefited from what Christ did for us on the cross in that He took away the

power of sin over us in life and death. He buried the old man *or* our old nature to death so that the body is no longer a slave to sin. The new man *or* new nature comes forth in the readiness to live a new life dedicated to the purpose of righteousness. This is a divine process. Unfortunately, too many of us join the church and never become one with Him in fellowship because we do little or nothing to foster a relationship with Him. Men with their lips say they accept Him as their personal Savior, but their handbook for survival, the Bible, is collecting dust.

Romans 6:8-13 *The Dake KJV*

"*8Now if we be dead with Christ, we believe that we shall also live with Him. 9Knowing that Christ, having been raised from the dead, dies no more: death no longer has dominion over him. 10For in that he died, he died to sin once: but in that he liveth, He liveth unto God. 11Likewise reckon ye also yourselves to be dead indeed unto sin, but alive unto God through Jesus Christ our Lord.*" When Christ rose from the grave He was resurrected and could die no more. That ended death's reign over Him. He died for sin once and for all, but lives to God. In the same way if we believe, we are dead to sin and can rest assured that we are alive to God through Jesus Christ our Lord. The death of Christ not only paid our sin penalty, but God also used it to break the power of sin over lives. If you want to be victorious, you can. We don't have to walk around saying "*the devil made me do it*", because we have the victory over Satan. All we have to do is resist him.

Verses 12 and 13 tell us, "*Therefore do not let sin reign in your mortal body, that you should obey it in its lusts. 13And do not present your members as instruments of unrighteousness to sin, but present yourselves to God as being alive from the dead, and your members as instruments of righteousness to God. For sin shall not have dominion over you, for you are not under law but under grace.*" One thing the Apostle is saying here is that we still must choose between good and evil. The Christian, the believer, can live his life as a victim and not a victor if he doesn't understand and exercise the power he has over sin and death. Paul says, "Do not let sin rule your physical body so that it responds to the things that it lust after. Do not surrender yourselves up as instruments of unrighteousness of sin, but give yourselves to God, alive as one who has been given a new life and the members of your body so that He can use you for righteous purposes." Sin should not rule over our lives because we are not under the law, but under grace. Grace is unmerited favor, the unlimited mercy of our Lord and Savior Jesus Christ. It is important that Christians understand this. The power and authority He has given us is something unredeemed man does not have, that is why he is a

slave to sin. Sin cannot rule over you unless you allow it too. The good thing about being under grace is you don't need a law to define what wrong is. The Holy Spirit will convict you to teach you what is wrong and you won't feel comfortable because it is no longer a part of your new nature. Take this for example, there is not a commandment among the Ten Commandments that says verbatim that you should not gossip, but by conscience we know that it is wrong and the Holy Spirit will convict when you do it. The Holy Spirit that dwells in you teaches you that it is not becoming the character of Christ.

Romans 6:14-18 *KJV*

¹⁵What then? Shall we sin because we are not under the law but under grace? Certainly not! ¹⁶Do you know that to whom you present yourselves slaves to obey, you are that one's slaves whom you obey, whether of sin leading to death or of obedience leading to righteousness? ¹⁷But God be thanked that though you were slaves of sin, yet you obeyed from the heart that form of doctrine to which you were delivered. ¹⁸And having been set free from sin, you became slaves to righteousness. Notice that the question the Apostle asked here is similar to the question in verse 1, "What then? Shall we sin because we are not under the law, but under grace? And he answered it, "Certainly not!" He explains that the nature of your behavior will show who you serve. We are servants to whoever we surrender the members of our body to? We are either a servant to sin and death *or* to obedience to righteousness. Our relationship to sin and death changes when we are no longer servants to it. We have the power to refuse to let sin rule over our lives and we must exercise that power with authority.

What does it mean to be a slave to sin or the devil?

Let's say, for example, that you were hurt by someone, a friend, spouse, or someone else, and you hate them for what they did to you. Jesus instructions to us are to forgive others if we want Him to forgive us. You have to make the decision to let go of hatred so that you can be made right with God. Jesus helps us with these things. All we have to do is give it to Him. If you refuse to forgive, hatred can sit in your heart for long time. It can even manifest itself into bitterness, resentfulness or something far worst. You may even become vindictive and if you do, you may not stop any anything until you have "gotten even". Getting even can be as serious as murder. If you won't let go, all you do is become a slave to the devil. He will use hatred in your heart to steal, kill, and destroy you and maybe even someone else. In the same way that sin was crouching at Cain's door, it will be crouching at your door.

Romans 6:19-23 *Dake KJV*

I speak after the manner of men because of the infirmity of your flesh: for as ye have yielded your members servants to uncleanness and to iniquity unto iniquity; even so now yield your members servants to righteousness unto holiness. 20-For when ye were the servants of sin, ye were free from righteousness. 21-What fruit had ye then in those things whereof ye are now ashamed? For the end of those things is death. 22-But now being made free for sin, and become servants to God, ye have your fruit unto holiness, and the end everlasting life. 23-For the wages of sin is death; but the gift of God is eternal life through Jesus Christ our Lord.

"I", Self, Known as the Old Man Must Die

In identifying the old nature, we have to be conscious of self. In past times, I've been guilty of saying and I hear people say, *"I can't help the way that I feel"* and we respond to something or someone negatively perhaps with hatred or resentment. I've heard people say, *"I'll lay my religion down and pick it back up again."* Self and the old man are acquaintances. Your behavior indicates whether that old man, that old nature has been put to death or not. If the old nature is still in charge, either you have not been born again or you don't understand the power you have over the old nature. If you have been baptized with the Holy Spirit of Christ, you have the power to say to the old nature, ***"I'm a new creature in Christ Jesus"*** and you can walk in this new life in obedience to righteousness. When the old man is dead, you begin to say, *"Not my will, Lord, but yours."* You learn to operate not by how you feel, because what you feel may be contrary to righteousness. Remember that you serve the one to who you surrender the members of your body to obey. When we surrender our will to God, we are able to allow the lead of the Holy Spirit. We learn to decrease self so that He can increase in us. This is where spiritual growth begins, in submitting to the one you have chosen to serve and becoming a servant to righteousness.

We've learn from the Apostle Paul that we are divinely delivered from sin and death through Christ and the Holy Spirit. When we understand and utilize the power that Christ gave us when He went to the cross, we will no longer be slaves to sin.

The death of Jesus Christ paid the penalty for our sin. His burial made it possible for the old man to die and the new man to fellowship with Him. His resurrection made it possible for our mortal bodies to be resurrected and reunited with our immortal soul and spirit. I Corinthians 15:55-57 says, ***"O death, where is thy sting? O grave, where is thy victory? The sting of death is sin and the strength of sin is the law. But thanks be to God which gives us***

the victory through our Lord Jesus Christ." Romans 6:23, "**For the wages of sin is death, but the gift of God is eternal life through Jesus Christ our Lord.**"

Today's Relevance

Chapter 6 of Romans is powerful. I'm convinced that most Christians don't understand the power that God gives us over sin and death, because too many of us live our lives as victims instead of victors. We talk the talk, but we don't walk the talk. More Christians are aborting babies than none Christians, living in sin and trying to hide one sin with another sin. We become slaves to sin at our own choosing. The lust of the flesh will take you there if you let it. When we learn to exercise the power we have over sin and death, we can live lives free of fornication, adultery, homosexuality, etc. Because we have power over sin and death, we don't have to become victims to HIV, AIDS, STDs and murderers of babies. Instead of living defeated lives under condemnation, we can live victorious lives. Condemnation says, "*If you don't hide this sin, everyone will know.*" Condemnation says, "*You know you can't take care of another child.*" Condemnation says, "*You know that the father of your unborn baby is married to another woman.*" Condemnation says, "*Because of your position you can't afford for anyone to know about your mistake.*" "Condemnation says, "*You were born this way so you might as well accept it.*" Condemnation is what thrusts you into committing yet another sin and causing you to become a slave to sin. Do you know the story of David and Bathe Sheba? David thought his sin was hidden until Nathan, the prophet, said, "*David, you are that man.*"(II Samuel 12:1-9) We may be able to hide some of our sins from each other, but we can't hide any of them from God. We suffer condemnation from each other, but not from God. All you have to do is humble yourself and come to the throne of grace seeking mercy that you may find His grace in your time of need. He is the one who forgives us and exonerates us. Why is it that we seem to care more about what man thinks than we do God? Man doesn't have a heaven to put us in, but if we care more about what man thinks than we do God, he can cause us to go to hell.

Oh, I know, we all have our desires. If we don't submit them to God and His righteousness, we will become heirs of the slave-master and victims of his wickedness. Romans 8:37 says this, "**...in all these things we are more than conquerors, through him that loved us.**" That is a **talk** that we can **walk** if we will try to understand and exercise the power He gave us over sin and death.

Quiz -- Romans 6

Select the best answer.

1. Something divine happens to us when we are baptized in Christ Jesus, we are baptized unto His
 a. Life
 b. Praises
 c. Family
 d. Death

2. Because Christ died for us on the cross
 a. We will all go to heaven
 b. We have another chance at eternal life
 c. It is no longer important what we do in our lives
 d. All of the above.

3. We benefited from what Christ did for us on the cross in that He
 a. Took away the power of sin over us in life
 b. Took away the power of sin over us in death
 c. Crucified the old man with Him
 d. All of the above

4. When we are dead to sin
 a. We should walk in the newness of life
 b. We are new creatures in Christ
 c. We are no longer slaves to sin
 d. All of the above.

5. When Christ died and rose again He
 a. Took the sting out of death
 b. Gave us victory over the grave
 c. Became submissive to mankind
 d. Both a and b

ROMANS 7

CONQUERING SIN IN OUR LIVES

Points Covered

- The flesh is controlled by the law of sin.
- The law taught man what sin was.
- The Law of the Mind and the Law of Sin Wages War to Rule.
- The sinful nature of man is the lustful flesh that controls him when he wants to do good and evil is always present.
- The war with sin is won only one way and that is through Jesus Christ.

How well you understand the gospel is determined by how well you receive and applies what is in Romans Chapters 7 and 8.

Romans 7:1-4 *NCV*

¹Brothers and sisters, all of you understand the Law of Moses. So surely you know that the law rules over people only while they are alive. ²For example, a woman must stay married to her husband as long as he is alive. But if her husband dies, she is free from the law of marriage. ³But if she marries another man while her husband is still alive, the law says she is guilty of adultery. But if her husband dies, she is free from the law of marriage. Then if she marries another man, she is not guilty of adultery. ⁴In the same way, my brothers and sisters, your old selves died, and you became free from the law through the body of Christ. This happened so that you might belong to someone else—the One who was raised from the dead—and so that we might be used in service to God. The Apostle Paul uses marriage to describe the old relationship of sin to a new relationship to God. He says brothers and sisters, "You know

what the Law of Moses says about marriage, that a woman is not free to marry another as long as her husband lives. If she does, she is guilty of adultery, but if he dies, she is free to marry another and is not guilty of adultery. Death broke all marriage bonds. Here Paul explained to the Jews that by comparison when you gave yourself to the Lord Jesus Christ, you became dead to the law. Your unity with Him broke the stronghold that the law had over you, so that you could be fruitful to God.

This is an excellent time to stop and have a group discussion. Consider the following discussion.

Group Discussion

In Chapter 7:1-4 the law of marriage is used to illustrate the new relationship we have with Christ. Some Christians still interpret this law to the letter and will not remarry if they have been divorced or had to divorce their spouse unless he/she dies. If we are to interpret the law to the letter, in what way did Jesus make us free? Answer and explain. Back up your answers with scriptures.

Romans 7:5-6 *NCV*

⁵In the past, we were ruled by our sinful selves. The law made us want to do sinful things that controlled our bodies, so the things we did were bringing death to us. ⁶In the past, the law held us like prisoners, but our old selves died, and we were made free from the law. So now we serve God in a new way with the Spirit, and not in the old way with written rules." When we were in the flesh, the sinful things we did were exposed by the law to destroy us. When we were dead in sins while under the Law of Moses, we were helpless to free ourselves from its bondage and death. He says, "There was a time when we served God in the old literal sense of rituals and forms, but now in a *true* spiritual way. We are set free from the law that condemned us and held us captive. We serve with a new spirit. We do the right things, not because we have a set of rules we follow, but because we are one with Christ whose Spirit lives in us."

Romans 7:7-13 *NCV*

In verses 7-13, to show the power sin has over the flesh. He reveals what he experienced until he came into the knowledge of Christ and allowed the power of the Holy Ghost to lead, guide, and empower him. Paul begins by telling us how he was bound by sin and describes sin as a self-acting spirit which at one time controlled and worked in him all kinds of sinful lusts. What kind of life are you living? Do you feel trapped in a misfit body? Listen to what the Apostle says in Verses 7-9 reads, "***You might think I am saying that sin and the law is the same thing. That is not true. But the law was the only way I could learn what sin meant, I would never have known what it means to want to take something belonging to someone else if the law had not said, "You must not want to take your neighbor's things***. (Thou shall not covet.) [8] ***And sin found a way to use that command and cause me to want all kinds of things I should not want. But without the law, sin has no power.*** [9]***I was alive before I knew the law. But when the law's command came to me, then sin began to live,*** [10]***and I died. The command was meant to bring life, but for me it brought death.*** [11]***Sin found a way to fool me by using the command to make me die.*** [12]***-So the law is holy, and the command is holy and right and good.*** [13]***-Does this mean that something that is good brought death to me? No! Sin used something that is good to bring death to me. This happen so that I could see what sin is really like; the command was used to show that sin is very evil.***" In other words, Paul is saying, "Don't misunderstand me that I'm saying the law is the same thing as sin, I'm not saying that. Before the law, sin had no power, because there was nothing to identify it. The law came and told me what sin was. Sin (a self-acting spirit) found a way to use it to stir up all kinds of selfish desires in me. Before the law, I didn't consider all the things I was doing wrong and evil. When the law identified all of the things I was doing wrong with my body, then my body (or my flesh) struggled that much more to satisfy its lust. Sin used the commandments (something good) to exercise control of my life and pressured me to disobey the law. The law had no power to help me instead all it did was condemned me to die. This happened so that I could see and understand what sin is like and how evil it is. This is every man's challenge to conquer sinful flesh.

The Apostle continues to show in the succeeding verses how he wrestled with sin in the flesh until he discovered the solution to his dilemma.

Romans 7:14–20 *NCV*

He continues in verses 14–20, "***We know that the law is spiritual, but I am not spiritual since sin rules me as if I were its slave. ¹⁵I do not understand the things I do. I do not do what I want to do, and I do the things I hate. ¹⁶And if I do not want to do the hated things I do, that means I agree that the law is good. ¹⁷But I am not really the one who is doing these hated things; it is sin living in me that does them. ¹⁸Yes, I know that nothing good lives in me—I mean nothing good lives in the part of me that is earthly and sinful. I want to do the things that are good, but I do not do them. ¹⁹I do not do the good things I want to do, but I do the bad things I do not want to do. ²⁰So if I do things I do not want to do, then I am not the one doing them. It is sin living in me that does those things.***" Can you identify with Paul's experience? "Are you a person who is always in trouble?" Are you a trouble-maker? In other words, when things are at peace, you do something to start trouble. Are you in and out of jail because you are always breaking the law, etc? Do you, after you have done things, wonder how you got yourself into such a situation? Do you ever stop to think who or what controls you? Sin (a self-acting spirit) can control your body and make you do all sorts of things. Jesus died on the cross so that you can have control over your own flesh. The choice is yours to make. You can be a slave to sin by letting Satan control your flesh or you can humble yourself to the Lord Jesus Christ and let Him have rule over your life so that you can live it abundantly.

Has there ever been a time when you wanted to do the right thing, but the stronghold of wrong was over you? Paul's experience brought him to the awareness of the triune of man – body, soul and spirit and he teaches it here so that we can understand the nature of sin Adam's disobedience left on mankind. The *body* is referred to as the *flesh* and the soul and spirit of man is referred to as the *inward man*. He is saying here, I know that the law is spiritual and man is carnal or worldly, but if I'm controlled by the forces of evil around me, I'm not spiritual. Paul realized that while he wanted to do well his flesh was doing things he hated because of its sinful nature. His mind was willing, but his flesh was weak. The spirit of man knows God so he knows right from wrong. He said, "*The good that I would do, I don't do it and the evil that I wouldn't do I do, because my will is overpowered by the lusts of sin in my flesh. I am helpless to defend myself.*" In other words, his will, reason, understanding, and conscience were on God's side, but his slave master would not consent for him to serve God.

The Triune of Man

Body (Flesh)	Soul – (Inward Man)	Spirit – (Inward Man)
Body (Flesh) Lust I Cor. 2:14 "The Natural man does not receive the things of the Spirit of God…"	**Soul – (Inward Man)** (Desires, Passions) Carnal or Spiritual Romans 12:2 "…be ye transformed by the renewing of your mind…"	**Spirit – (Inward Man)** Conscious of God Regeneration takes place I Cor. 2:11-12 For what man knows the things of a man, except the spirit of the man which is in him…"

The law itself was holy and the commandment was right, but it didn't have the power to make one do the right thing. It didn't have the power to forgive or pardon one's sin. It could only condemn and penalize one because of its infraction. That is because the law merely symbolizes the gospel and can only be fulfilled by the gospel. In St. Matthew 15:17 *KJV* Jesus said, "**Do not think that I came to destroy the Law or the Prophets. I did not come to destroy but to fulfill.**"

As the Apostle described how he wrestled with sin, he shows how he became aware of the *law of the mind* and the *law of sin*. He continues in Romans 7:21-23, "**²¹So I have learned this rule: When I want to do good, evil is there with me. ²²In my mind, I am happy with God's law. ²³But I see another law working in my body, which makes war against the law that my mind accepts. That other law working in my body is the law of sin and it makes me its prisoner.** The King James Version of verse 21 reads this way, "**I find then a law, that, when I want to do good, evil is present with me.**" This is the *law of the mind* that Paul becomes aware. He said, "In my mind, in my inward spirit, I am happy with God's law, but I see another law that is always at work in my body and that is the *law of sin* which makes me a prisoner. I'm sure that you can think of one of the Ten Commandments that you agree is right, but if sin is your slave-master, you are not able to obey it. Sin is a spirit that can dwell in you and exercise power over the flesh and cause you to do wrong when it is not your will to do wrong. Are you a prisoner of the law of sin? Read this scenario and think about it.

Scenario

A man sees a picture of a nude woman in a magazine (or on the Internet) and immediately he begins to lust. A seed has been planted in his mind. The man enjoys the feeling that he got and doesn't resist it, so he returns again and again to the same picture. Soon he begins to nurture his feeling more

and more. He begins visiting pornographic websites, buying pornographic magazines, videos, etc. As he nurtures his thoughts with more and more pornography, the desire to carry out his fantasies on an actual person begins. The stronghold of sin in the flesh will cause him to act upon his lustful desires. He may get involved in a consensual relationship that is wrong, someone could become his victim or he could become addicted to pornography. Whatever the case, he will soon realize that he is a slave to the lusts of the flesh. He may even feel like a victim himself, when he sees that he can't help himself. He feels trapped. That is the stronghold that sin can have over the flesh. This can happen to a woman as well. It doesn't have to be sexual sin. It can be any sin. Anytime you refuse to surrender your will to God's will, you are a slave to your own lustful desires. Your attitude is "It's my way or no way." The Bible says, "**Submit yourself to God; Resist the devil and he will flee from you.**" If you never resist him he is not going anywhere until he has you right where he wants you, his slave.

Romans 7:24-25 *The Dake KJV*

Paul continues in 7:24-25 KJV (preferred reading), "**O wretched man that I am! Who shall deliver me from the body of this death? ²⁵I thank God through Jesus Christ our Lord. So then with the mind I myself serve the law of God; but with the flesh the law of sin.**" In verse 24 the Apostle Paul expresses disapproval of himself when he was in this condition and called himself a wretch (a distressed or trouble person who evokes pity in others). He asked the question "*A distressed man that I am! Who will help me with this body that is destined for hell?*" When he learned the answer, He said in verse 25, "*I found the answer in Jesus Christ our Lord. Through Him I can please God and be more than a conqueror.*" This is why Paul admonished the Philippians in chapter 2:5 "**Let this mind be in you which is in Christ Jesus.**" When you love Him, you have a mind to please Him. When you have a mind to please Him, you can serve God and not be a slave to the law of sin in the flesh. That is what the songwriter, John Newton, discovered and he sang, "*Amazing grace how sweet the sound that saved a wretch like me. I once was lost but now I'm found, was blind but now I see.*"

The fall of man in the Garden of Eden left all mankind in a sinful state. While that sinful state has power over the body, it does not have power over the inward man (soul and spirit) when man chooses to serve the Lord Jesus Christ. In St. Matthew 10:28 Jesus said, "**Do not fear those who kill the body but are unable to kill the soul; but rather fear Him who is able to destroy both soul and body in hell.** Jesus is the only one with the power to crucify the flesh, to kill our old sinful natures and make us right with Him. He is the only one that has power over the body and the soul. A person can be on death row and come to Christ.

While the penalty of the physical death may still be upon that person, spiritual death is removed. Hallelujah!

So what was Paul's point in all of this? The war with sin is won only through Jesus Christ, our Lord and Savior. The flesh wages war with inward man and wins until the inward man surrenders to the Lord Jesus Christ. He can then sing with conviction, *"All to Jesus I surrender, All to Him I freely give; I will ever love and trust Him, In His presence daily live. I surrender all!"* It is then that he can crucify the flesh and through the Lord Jesus Christ be more than a conqueror. This is why Paul could say in Romans 8:1-2, ***"There is therefore now no condemnation to them which are in Christ Jesus who walk not after the flesh, but after the Spirit. ²Through Christ Jesus the law of the Spirit that brings life made you free from the law that brings sin and death."***

Today's Relevance

In this passage of scripture the Apostle Paul used the marriage laws of that day to explain our new life in Christ Jesus. This is a question that I'm asking Christians, and it is not to condone divorce, but help us think clearly what it is He wants us to do and how He wants us to live. God did not create divorce, but Moses established laws to protect the victims of bad marriages and God accepted the law, but added that divorce should only be on the grounds of adultery. See St. Matthew 19:3-12. Many have been divorced at no fault of their own. Some have divorced because they have been beaten, abused, mistreated, and to get away from a very bad situation, they had to do what they had to do. If Christ died so that we are now dead to the law, why do we allow ourselves to be held in bondage to the law? The law says you cannot remarry until your spouse is dead? How many saints do we have sitting around hoping that their ex-spouse will hurry up and die? And not only that, if you haven't allowed Him to help you subdue the lust of the flesh and you're fornicating, doesn't that make you a hypocrite? So that we are not hypocritical, these are things that we have to pray on and allow Christ and the Holy Spirit to be our guide.

What Paul taught made me think about all the bad habits; such as, drugs, alcohol, abusiveness, lying, cheating, sexual immorality, etc. I think about the deviant sexual behaviors that have left our society plagued with diseases, such as HIV, AIDS and a host of Sexually Transmitted Diseases (STDs) that weren't even around 25 years ago. It makes me think of gangs, terrorist acts, and other sinful natures that are corrupting our society and creating fear in people. I think about the racism that exists. We war with them in the flesh. We war flesh against flesh, but it is a war that we can't win with the flesh. This is why

this lesson is so relevant to us today. While technology changes, modes of transportation changes, and numerous other things have changed since the beginning of time, human nature does not change. People still murder, steal, lie, cheat, etc. We've learned from the Apostle Paul that the only way to win the war with the flesh is through the gospel of Jesus Christ.

Romans 7 -- Quiz

Answer True or False. For multiple choice items, select the best answer. Complete essay items as directed.

1) ***True or False***. The Ten Commandments, which is also called the Law of Moses is now abolished.

2) In the past, the law held us like prisoners, but now
 a. Our old selves died
 b. We are made free from the law
 c. We serve God in a new way with the Spirit
 d. All of the above

3) Sin is described like a
 a. Sword for destruction
 b. Wild animal devouring its prey
 c. Self-acting spirit
 d. Like the devil's wife

4) What is the triune of man?
 a. Joy, peace, happiness
 b. Father, Son and Holy ghost
 c. Baptism, Spirit, Deliverance
 d. Body, soul, spirit

5) Now that man is free from the law, he serves God in a new way. What way is that?
 a. With his voice
 b. Walking in the light
 c. Walking in the Spirit
 d. Keeping the commandments

6) The answer to winning the war over sinful flesh is
 a. Praising God with all your might
 b. Praying without ceasing

 c. Jumping and leaping for joy

 d. Faith in the Lord Jesus Christ

7) **True or False**. Sin has power over the body, but it does not have power over the inward man (soul and spirit) when man chooses to serve the Lord Jesus Christ.

8) With the _____ we can serve the law of God; but with the flesh we serve the law of _____.

ROMANS 8

LIVING VICTORIOUSLY

Points Covered

- The Law of the Spirit teaches us how to win the war.
- We win the war over sin in the flesh by walking after the Holy Spirit.
- We lose the war over sin in the flesh by walking after the lusts of the flesh.
- If Christ is in you, the Holy Spirit is in you.
- If you follow the lusts of the flesh, you will die spiritually.
- If you use the Spirit's help, you will have true life.
- We must suffer as Christ suffered so that we will have glory as He has glory.
- Our sufferings cannot compare to the great glory that He will show us.

In Chapter 8 Paul teaches how to walk in the counsel of the Spirit and not after the lusts of the flesh. In Chapter 7, we learned from God's chosen vessel the influence that sinful flesh has over the inward man (soul and spirit) *apart* from the Lord Jesus Christ, but Paul discovered how to conquer the flesh and he shared his experience in the letter to the Church at Rome. He spoke in the first person and explained how he wrestled with sin in the flesh and what he found out the solution was. God taught him to distinguish between the law of the mind and the law of sin that worked in his flesh. He learned that winning the war against the sin of flesh was surrendering his mind to the Lord Jesus Christ and following the *law of the Spirit*. The Holy Spirit will teach you and give you the power to crucify the deeds of the flesh. When you honor, obey and trust God, then you won't walk after the lust of the flesh, but you will follow the leading of the Spirit.

Romans 8:1-5 *NCV*

After going through life-changing experiences himself, Paul is able to share with conviction his experience in Chapter 7 and Romans Chapter 8:1 KJV. Verse 1 reads, "***There is therefore now no condemnation to them which are in Christ Jesus who walk not after the flesh, but after the Spirit.***" In the NCV it reads, "***So now, those who are in Christ Jesus are not judged guilty.***"

It continues, Romans 8:2-5 NCV, "***Through Christ Jesus the law of the Spirit that brings life made you free from the law that brings sin and death. ³The law was without power, because the law was made weak by our sinful selves. But God did what the law could not do. He sent his own Son to earth with the same human life that others use for sin. By sending his Son to be an offering for sin, God used a human life to destroy sin.*** God gave mankind everything he needed to conquer sin and death. He sent His only begotten son, Jesus, to pay our sin debt and the Holy Spirit to bring us life and power, and the Word of the New Covenant to teach us about this new way of life. God gave the Law of Moses as man's school teacher on behavior at the beginning of time. While it taught man what was right, it did not have the power to make man obey it. What the Law of Moses could not do because it was weak through the flesh, God sent his Son to complete. He became flesh in human form to condemn sin in the flesh. ***⁴He did this so that we could be the kind of people the law correctly wants us to be. Now we do not live following our sinful selves, but we live following the Spirit. ⁵Those who live following their sinful selves think only about things that their sinful selves want. But those who live following the Spirit are thinking about the things the Spirit wants them to do.***" The righteousness of the law could be fulfilled in those who walk after the Spirit. We learn to focus on the things of the Spirit instead of the carnal or our own fleshly desires. For our inward man to be strong we must nourish ourselves with Spiritual things. When I began to nourish myself in the Word of God, my interest shifted from the carnal to the spiritual. My appetite includes mutual Christian friendships, Gospel music, study of the Bible, Christian and other clean television programs, religious radio programs, etc. My interests are not limited exclusively to these things. I enjoy other wholesome activities, but I guard my heart and mind from a lot of foolishness. If a day or week goes by that you fail to get the spiritual nourishment that you need, you will know it.

St. Matthew 5:6 says, "***He who hungers and thirst for righteousness shall be filled.***" If you are a Christian and don't have the desire to study your Bible and attend Bible study classes, let one of your prayers be for a hunger and thirst for righteousness. The inward man should be nourished in the things of God so that the Holy Spirit can take charge of

your inward person. You will know your true identity so that when Satan tempts you, you will be steadfast, unmovable and abounding in the faith. Another important reason we study our Bibles is so that we are aware of heresy or false doctrines. Many have been led astray by false doctrines. Satan has a lot of lies going around, especially on the Internet so be careful what you absolve. Read along with preachers and teachers as they teach the gospel. Study your Bible. Learn to listen to the Holy Spirit and allow Him to lead, guide, and teach you.

Group Discussion: Discuss how you think you should nourish your inward man so that you do not lust for the things of the flesh.

Romans 8:6-16 *NCV*

Romans 8:6-16, shows the contrast between having a *Spiritual mind* and a *carnal mind*. It reads, "***⁶If people's thinking is controlled by the sinful self, there is death. But if their thinking is controlled by the Spirit, there is life and peace. ⁷When people's thinking is controlled by the sinful self they are against God, because they refuse to obey God's law and really are not even able to obey God's law. ⁸Those people who are ruled by their sinful selves cannot please God. ⁹But you are not ruled by your sinful selves. You are ruled by the Spirit, if that Spirit of God really lives in you. But the person who does not have the Spirit of Christ does not belong to Christ.*** We cannot love the world and love God, too. James 4:4 verifies this, "***...anyone who chooses to be a friend of the world becomes an enemy of God.***" If you love the things of the world more than you do God, those are the things you will desire and be controlled by. You will not follow God's commands, because you can't. Without God's help, you don't have power over sinful flesh. If you have accepted Christ as your savior, and you allow yourself to be led by the Spirit and you will have life and peace even when you go through trials.

¹⁰Your body will always be dead because of sin. But if Christ is in you, then the Spirit gives you life, because Christ made you right with God. ¹¹God raised Jesus from the dead, and if God's Spirit is living in you, he will also give life to your bodies that die. God is the One who raised Christ from the dead and he will give life through his Spirit that lives in you. By contrast, the opposite is the case for the person who does not have the Spirit of Christ in them and if a Christian does not exercise the power that is within them they, too, can be a victim. If the Spirit of Christ is not in you, your body does not have power over sin. I guess you've heard the statement "*The devil made me do it.*" The devil can tempt you do a lot of things and when you do them, he sits back and laughs. Your trials can "break you to

make you." Many people have relied on drugs and alcohol to fix them or money to sustain them and have die because they did not grab hold to the life line that God gave them, His only Son who went to the cross for them, Jesus. Sometimes people yield to God when they realize there is no one else with the power to help them. When they realize that God is the only one who can help them, they humble themselves and that's good. Psalm 51:17 says, "***A broken and contrite heart He does not despise.***"

^12***So, my brothers and sisters, we must not be ruled by our sinful selves or live the way our sinful selves want.*** If you sincerely believe and accept Christ as your personal Savior, the Holy Spirit lives in you. But you must still make the choice to let Him lead, guide and teach you. ^13***If you use your lives to do the wrong things your sinful selves want, you will die spiritually.*** If you fail to let the Spirit help you, you will sin. Sin separates us from God and we lose fellowship with Him. ***But if you use the Spirit's help to stop doing the wrong things you do with your body, you will have true life.*** ^14***The true children of God are those who let God's Spirit lead them.*** ^15***The Spirit we received does not make us slaves again to fear; it makes us children of God. With that Spirit we cry out, "Father."*** ^16***And the Spirit himself joins with our spirits to say we are God's children."*** If we allow the Holy Spirit to lead, guide and teach us, we grow in grace. We see change in our lives. Our faith in God increases. We have hope for a better tomorrow. We are not victims of our circumstances, but conquerors, because we rise above our situations, because we know who to call on for help. When the Spirit joins with our spirits, He recognizes us as His own. Now let's look at the contrast between the two in another way.

The Carnal Minded

People want the benefits of salvation, but they want to remain the same. To be *carnal minded* is to be worldly; which means your focus is on material and fleshly desires. The Apostle Paul cites twelve things that a *carnal mind* results in: *1)* If you are controlled by the flesh, there is death, 2) it means you have a mind against God, 3) you cannot please God, *4)* you do not belong to God, 5) He does not dwell in a carnal mind, 6) Sinful flesh rules, 7) God's ***Spirit*** does not live in a carnal minded person, *8)* a carnal minded person is indebted to the flesh. He is helpless to defend himself from sinful flesh, *9)* a carnal mind lives after the flesh and dies in sin, *10)* carnal minded persons are not Sons of God, *11)* they are under the spirit of bondage to fear, and *12)* the Holy Spirit doesn't acknowledge a carnal minded person as being one of God's children. This is why Christians should not allow themselves to be ruled by a carnal minded.

The Spiritual Minded

By contrast, Paul said being **spiritual minded** means you focus on things of the Spirit and as a result: 1) you have life and peace, because you learn to let go and let God, 2) you are subject to God, 3) you can please God, 4) the Spirit of God dwells in you, 5) you belong to God, 6) your body will always be dead because of sin, but the Spirit of Christ will give you life, 7) the Spirit of Christ will quicken your mortal body, 8) The Spirit of Christ makes you right with God, 9) Through the Spirit you mortify the deeds of the body so that you will have *true life*, 10) God's Spirit leads you, 11) By the Spirit of adoption, you are children of God and not a slave to fear and, 12) the Spirit bears witness with your spirit that you are true children of God. That is a twelve-fold contrast between the carnal mind and the spiritual mind.

Romans 8:17-18 *NCV*

What are the eternal results of being delivered from sin? Read what Paul says, "**[17]If we are God's children, we will receive blessings from God together with Christ. But we must suffer as Christ suffered so that we will have glory as Christ has glory. [18]The sufferings we have now are nothing compared to the great glory that will be shown to us.**" As God's children we will receive His blessings, but remember that Christ suffered so that we would be able to experience God's glory. The world didn't like Him, and it won't like those who are in Christ. Jesus said in Matthew 16:24, "**If any man will come after me, let him deny himself, and take up his cross, and follow me**." Just as He suffered, we must suffer also. But the suffering we experience will be nothing compared to the great glory that will be shown to us now and later. The cross here are the things that we will suffer for Christ sake. When Jesus was arrested in the Garden of Gethsemane, His disciples were afraid of what would happen to them, too. After they were filled with the Holy Ghost, they were different men. They were willing to risk their lives for the gospel and many became martyrs for it. They no longer lived in the bondage of fear. The Spirit within them bore witness that they were true Sons of God.

Romans 8:19-23 *NCV*

"**[19]Everything God made is waiting with excitement for God to show his children's glory completely. [20]Everything God made was changed to become useless, not by its own wish but**

because God wanted it and because all along there was this hope: ²¹that everything God made would be set free from ruin to have the freedom and glory that belong to God's children. ²²We know that everything God made has been waiting until now in pain, like a woman ready to give birth. ²³Not only the world, but we also have been waiting with pain inside us. We have the Spirit as the first part of God's promise. So we are waiting for God to finish making us his own children, which means our bodies will be made free." When God created the world, everything He created was good. Sin caused everything He created to lose its perfect state. The things He created wait for Him to glorify His real children and return them to their original state. We have the promised that one day our mortal bodies will be changed to immortal and we will no longer suffer from sickness, disease and death. We have the first part of His promise and that is the Holy Spirit. He helps us when we are weak. When we can't pray or don't pray as we should, the Spirit speaks to God. God sees our hearts and He knows what is in the mind of the Spirit and He makes intercession for the saints.

Romans 8:28-31 *NCV*

This is verse 28 from the NKJV, "*And we know that all things work together for the good of them that love God and are called according to His purpose.*" This is the NCV reading, "*We know that in everything God works for the good of those who love him. They are the people he called because that was his plan.* It continues, ²⁹*God knew them before he made the world, and he chose them to be like his Son so that Jesus would be the firstborn of many brothers and sisters. ³⁰God planned for them to be like his Son; and those he planned to be like his Son, he also called; and those he called, he also made right with him; and those he made right he also glorified.*" In the Old Testament, Joseph, the son of Jacob was sold by his brothers and he ended up being a servant to the Egyptians, he could have resorted to being bitter with his brothers and angry with God but he didn't. Joseph knew God and he worshipped Him even though he was in a foreign land in the midst of idol worship. In the end he learned that everything worked together for his good and for the whole nation of Israel that he helped to preserve according to God's calling and purpose for him. The suffering he experienced could not compare to the glory he experienced when he was made second in command in Egypt and was reunited with his family, but there is an even greater glory that he will experience. See the story of Joseph in Genesis, Chapters 37–50. Romans 8:31 reads, "*So what should we say about this? If God is for us, no one can defeat us.*" Christ Jesus died, was raised from the dead, and now he is sitting on God's right side, appealing to God for us and nothing can separate us from the love he has for us.

Romans 8:37-39 *NCV*

"But in all these things we are completely victorious through God who showed his love for us. [38]Yes, I am sure that neither death, nor life, nor angels, nor ruling spirits, nothing now, nothing in the future, no powers, [39]nothing above us, nothing below us, nor anything else in the whole world will ever be able to separate us from the love of God that is in Christ Jesus our Lord." I want you to know today, that there is no failure, no fault, and no area of sin in your life that the Lord Jesus Christ can't handle. There is no problem too big for Him that you can't trust Him to work it out for you. Even when you don't see it, He's at work. I've learned that with the help of Christ I can take my stumbling blocks and turn them into stepping stones. You can do the same. In Him, we are more than conquerors if we trust Him. When we are in Christ, we have the power to walk not after the flesh, but after the Spirit. It is God's intent that we be victors, not victims.

Today's Relevance

What do you do when your desires do not match up with Jesus' teaching? Do you give in to your desires? Do you stop and think about it and ask God for help? We all desire things that are not in line with the Word of God from time to time and I'm not just talking about material things and relationships. I'm also talking about behaviors. Sometimes we want to respond to people and situations by how we feel at a given moment. God will help us with those feelings, too, so that we can walk in righteousness if our desire to do what's right is more important to us than what we feel. That is why we have to be renewed in our minds. When we walk in righteousness, even in the midst of our trials we can experience peace, the joy of the Lord, and the excitement of growing spiritually. We enjoy the benefits of justification by faith in Christ Jesus.

Quiz -- Romans 8

Select the best answer or circle **true** or **false** and fill in the blanks.

1. The key to having power over sin is
 a. Following the Ten Commandments
 b. Worshipping each religious holiday
 c. Walking after the Spirit
 d. Not walking after the flesh
 e. Both c and d

2. **True or False**. God's Son destroyed the power of sin over our lives.

3. For the inward man to be strong, we must nourish him with
 a. Fear
 b. Unrighteousness
 c. The Scriptures and righteous things
 d. Comedy and talk shows

4. Distinguish between the things that are classified as *carnal* and the things that are *spiritual*. Write C on the line for Carnal and S on the line for the Spiritual things.
 a. _____Thinking is controlled by the Spirit.
 b. _____Chooses to be a friend of the world.
 c. _____Slaves to fear.
 d. _____Has life and peace.
 e. _____Has a mind against God.
 f. _____Has a mind subject to God.

5. As God's children we will receive _____ from God together with Christ. But we must _____ so that we will have glory with Him.

6. When God created the world, everything He created was good. _____ caused everything He created to lose its _____.

ROMANS 9

NO DISAPPOINTMENT IN JESUS

Points Covered

- Anyone who trust in God will never be disappointed
- Salvation is not by rituals, form, ceremonies, etc.

Romans 9:1-5 *NCV*

In Chapter 8, the Apostle Paul showed the contrast between being led by the Spirit and walking in the flesh. In Chapter 9:1-5 he expresses the burden he carries for his Jewish brothers and sisters and desperately tries to enlighten them. He said this, *"I am in Christ, and I am telling you the truth; I do not lie. My conscience is ruled by the Holy Spirit, and it tells me I am not lying. ²I have great sorrow and always feel much sadness. ³I wish I could help my Jewish brothers and sisters, my people. I would even wish that I were cursed and cut off from Christ if that would help them. ⁴They are the people of Israel, God's chosen children. They have seen the glory of God, and they have the agreements that God made between himself and his people. God gave them the Law of Moses and the right way of worship and his promises. ⁵They are the descendants of our great ancestors and they are the earthly family into which Christ was born, who is God over all. Praise Him forever! Amen."* In other words, "I'm telling you the truth, because I allow my conscience to be ruled by the Holy Spirit. If I could help my Jewish brothers and sisters by being cursed and cut off from Christ, I would. They are God's chosen people. They have seen Him work miracles first hand and have the covenants God made between them. He gave them the Law of Moses and taught them how to worship Him. They are descendants of our great ancestors, Abraham, Isaac, Jacob and the other prophets. Christ came through their lineage so that everyone could

have access to God, the Father. We should praise Him forever for that!" We can sense the tremendous burden Paul felt for his people. We, too, should allow our conscience to be led by the Spirit and when a burden for our brothers and sisters is placed upon us, we should pray for them without ceasing.

Romans 9:6-13 *NCV*

⁶It is not that God failed to keep his promise to them. But only some of the people of Israel are truly God's people, ⁷and only some of Abraham's descendants are true children of Abraham. But God said to Abraham: "The descendants I promised you will be from Isaac. ⁸This means that not all of Abraham's descendants are God's true children. Abraham's true children are those who become God's children because of the promise God made to Abraham. ⁹God's promise to Abraham was this: "At the right time I will return, and Sarah will have a son." In Romans 9:6-9, in an effort to convince the Jews he continues by teaching them what a real Jew is. He says, "Just being born physically into the family does not make you a Jew. Some of you are truly genuine. You are a real Jew, if inwardly you have circumcision of heart, in the spirit, and not in the letter; your praise is not of men, but of God. Some of you are not seed of Abraham and children of God, because you are children in the flesh. God made a promise to Sarah that she would have a son and she did. What He promised He delivers.

The scripture text continues *¹⁰And that is not all. Rebekah's sons had the same father, our father Isaac. ¹¹⁻¹²But before the two boys were born, God told Rebekah, "The older will serve the younger." This was before the boys had done anything good or bad. God said this so that the one chosen would be chosen because of God's own plan. He was chosen because he was the one God wanted to call, not because of anything he did. ¹³As the Scripture says, "I loved Jacob, but I hated Esau.* From Israel's history you know that God blessed Rebecca who was barren also like Sarah, she conceived a child for her husband Isaac so that the purpose of God according to His election might stand by His calling and not by the works of man. Rebecca conceived and had twins. God saw the disposition of the older one before he was born and didn't like it. He rejected Esau and chose Jacob, the younger one. In the KJV, the word *hate* is used to describe His feelings toward Esau. The word *hate* here is as an idiom of preference, not malice. Many even today have not accepted the promised seed that came through the covenant that was established through Isaac to be an everlasting covenant, and through, Jacob, the one that followed by election.

Paul had a burden for his Jewish brothers and sisters. Israel was God's chosen people, but many had not accepted Jesus as the Son of God. They did all of the religious rituals of that day, but they didn't do them with circumcision of heart and spirit. God's Spirit was not in them because Christ was not in them. By comparison, today, joining the church does not make us Christians. A person can give the pastor their right hand in fellowship with the church, but never give God their heart. If the Spirit of Christ is not in them, they do not belong to Him.

Romans 9:14-24 *NKJV*

[14]*"What shall we say then? Is there unrighteousness with God? Certainly not!* [15]*For he says to Moses, I will have mercy on whomever I will have mercy, and I will have compassion on whomever I will have compassion."* [16]*So then it is not of him that wills, nor of him who runs, but of God who shows mercy.* [17]*For the Scripture says to the Pharaoh, "For this very purpose I have raised you up, that I may show My power in you, and that My name may be declared in all the earth."* [18]*Therefore He has mercy on whom He wills, and whom He wills He hardens.* [19]*You will say to me then, "Why does He still find fault? For who has resisted His will?"* [20]*But indeed, O man, who are you to reply against God? Will the thing formed say to him who formed it, "Why have you made me like this?"* Paul here teaches the sovereignty of God. *Sovereign* means chief, supreme; above all others. God has the power to do whatever He wishes. Can we say to this that God was unfair and thus unrighteous? He then uses Israel as an example. Would you say that it is unfair for God to judge Israel when they are His chosen people? Then he answers, "Absolutely not! God showed His great power through the people and things He created. He is the ultimate authority and doesn't need anyone's permission to do what He chooses to do. For example, He chose Isaac over Ishmael. He chose Jacob over Esau. He raised Pharaoh up and hardened his heart so that he could demonstrate His power so that His name would be declared over the earth, but He also showed mercy on Israel. Who is man that he can wage a complaint against God? Can the creature ask the creator why he made him for his purpose?

[21]*Does not the potter have power over the clay, from the same lump to make one vessel for honor and another for dishonor?* [22]*What if God, wanting to show His wrath and to make His power known, endured with much longsuffering the vessels of wrath prepared for destruction,* [23]*and that He might make known the riches of His glory on the vessels of mercy which He had prepared beforehand for glory,* [24]*even us whom He called, not of the Jews only, but also of the Gentiles!* He is like a potter. A potter has power over a lump of clay. He can make

one vessel to honor, and another to dishonor if he chooses. But know this one thing that He remained patient with people He could have destroyed. He waited patiently so that He could show His rich glory on the vessels of mercy – Jews and Gentiles. It doesn't matter what your situation is, perhaps you were an orphan, an abused or neglected child. Perhaps you were wrongly accused and convicted of a crime you didn't commit. Perhaps you are a victim of rape or incest or whatever. God wants to show you His rich glory. If you trust Him and take Him at His word, He will take your situation and make a blessing with it. Don't think of yourself as one that has been cursed, but think of yourself as one that He loves and is just waiting to show to you His glory.

Romans 9:25-29 *NCV*

In Romans 9:25-29 he quotes the prophecy of Hosea and Isaiah, "*I will say, 'You are my people' to those I had called 'not my people." And I will show my love to those people I did not love." ²⁶They are called 'You are not my people,' but later they will be called 'children of the living God.'" ²⁷And Isaiah cries out about Israel: "The people of Israel are many, like the grains of sand by the sea. But only a few of them will be saved, ²⁸because the Lord will quickly and completely punish the people on the earth. It is as Isaiah said: "The Lord All-Powerful allowed a few of our descendants to live. Otherwise we would have been like the cities of Sodom and Gomorrah*." Israel's failure and unbelief is foretold by the Prophets. Isaiah was one of them. See Isaiah 10:22-23. The inclusion of the Gentiles was prophesied. They were called "not his people", but later grafted in so that they, too, could be called "children of the living God." Though Israel will be as many as the grains of sand on a sea shore, only a few of them will be saved. If the Lord of host had left them without a remnant, they would have been like Sodom and Gomorrah, completely destroyed.

We've already learned that God is sovereign and not a respecter of persons. He is all-powerful. He has chosen to call people who were not His chosen "*His people*" and call some of His chosen people, "*Not my people*". Because of His goodness and mercy, a few of them will be saved.

Romans 9:30-33 *NCV*

Verses 30-33 tell us the reason for their failure, "³⁰*So what does all this mean? Those who are not Jews were not trying to make themselves right with God, but they were made right*

with God because of their faith. *31*The people of Israel tried to follow a law to make themselves right with God. But they did not succeed *32*because they tried to make themselves right by the things they did instead of trusting in God to make them right. They stumbled over the stone that causes people to stumble. *33*As it is written in the Scripture: "I will put in Jerusalem a stone that causes people to stumble, a rock that makes them fall. Anyone who trusts in Him will never be disappointed." Non Jews were trying to live holy, but they were made holy by their faith in God. Israel's hope was in their ability to keep the Law of Moses, which couldn't do without trusting God. They tried to make themselves right with God by the things they did (rituals and forms) as oppose to trusting in God. Because they didn't trust God as they should, when He sent Jesus into the world to save them, they rejected Him. Jesus was that stone that the people rejected. He is described as a rock or stone that will cause people to stumble. You may never realize your true purpose and calling if you reject Jesus.

Today's Relevance

God is in complete control of His creation. He created everything with a purpose in mind. I can't understand why He created some things, but who am I to question why He created what He created. He chose Israel to be His chosen people. Why not the Chinese, Indians, Africans? Even if He had chosen another group, the question would remain, why not us? God chose Jacob over Esau. He sent His Son to be the Savior of the world. In John 14:6, Jesus said, "*I am the way, the truth, and the life; no man comes to the Father but by me.*" Jesus is the only way to the Father. He came into the world to save the whole world. Through Him and Him alone can one be saved. Salvation is not by ceremonies, rituals, forms, emotions, good law abiding citizenship, and the titles we wear. That is why ministers of notoriety keep making headlines in the media. We are fooling ourselves when we think that we can make ourselves right with God. We are fooling ourselves when we think that we can define what righteousness is apart from God's Word. We are fooling ourselves when we think we can vote and pass laws on what righteousness is. In thinking that we are wise, we become fools. Who do you trust today, man or God? If you trust God, you will never be disappointed.

Quiz -- Romans 9

Select the best answer or select True or False.

1. Paul was desperate to see his Jewish brothers and sisters saved. He expresses it by
 a. Being sad
 b. Desiring to be cursed if it would benefit them
 c. lying to convince them of God's great glory
 d. Both a and b

2. Who does Paul say that his conscious is ruled by
 a. The Ten Commandments
 b. A righteous man
 c. His faith
 d. The Holy Spirit

3. Paul reflected on Old Testament prophets and scripture to teach the Romans. One was the story of Isaac and Rebekah. Rebekah had twins and their names were
 a. Paul and Silas
 b. David and Goliah
 c. Abraham and Isaac
 d. Esau and Jacob

4. For God to say "I loved Jacob and hated Esau," it describes his feelings as
 a. Unrighteousness
 b. A matter of preference
 c. Malicious talk
 d. All of these

5. True or False. According to Paul, God saw Esau's disposition before he was born.

6. True or False. Israel is God's chosen people and because of that, they will not suffer the same penalties for sin as do the Gentiles.

7. True or False. All people born into a Jewish family are true children of Abraham.

ROMANS 10

SALVATION IS FREE

Point Covered

- Salvation is free to them that believe
- It is by one's faith in the Lord Jesus Christ we are saved.
- One should submit to God's righteousness.
- Whoever calls on the Lord (Jew or Gentile) will be saved.
- Faith is received by hearing the gospel of Jesus preached.
- Preachers are sent of God.

Romans 10:1–3 *The Dake KJV*

Paul begins in verses 1–3 with, "*¹Brethren, my heart's desire and prayer to God for Israel is, that they might be saved. ²For I bear them record that they have a zeal of God, but not according to knowledge. ³For they being ignorant of God's righteousness, and going about to establish their own righteousness, have not submitted themselves unto the righteousness of God*." Paul really wanted his Jewish brothers and sisters to be saved, because he has observed that they really wanted to know God, but they didn't know the right way to do it. They were trying to honor the Law of Moses but couldn't live it, because it wasn't something they could do alone. They tried to make themselves right with God by trying to establish what righteousness is themselves. They didn't know God's righteousness, because they hadn't submitted to His righteousness. Today, we see the same zeal in people who want God and His blessings, but they want Him on their terms. They give their right hand in fellowship to the pastor, but never give God their heart. They try to rationalize within themselves what righteousness is when His Word doesn't suit them, and they say

72

it is '*ancient and outdated*' or they go about trying to rewrite or reinterpret to justify their own righteousness. We fool ourselves when we do this. A lot of people who go to church are members, but not disciples.

Romans 10:4-8 *Dake KJV*

In Verses 4-8 Paul continued, "***For Christ is the end of the law for righteousness to every one that believeth. ⁵For Moses describeth the righteousness which is of the law, "That the man which doeth those things shall live by them. ⁶But the righteousness which is of faith speaks on this wise, Say not in your heart 'Who shall ascend into heaven?' (That is to bring Christ down from above: ⁷Or, who shall descend into the deep? (that is to bring up Christ again from the dead.) ⁸But what does it say? The word is nigh thee, even in thy mouth, and in thy heart: that is, the word of faith, which we preach***;" Christ came and ended the stronghold of the law for righteousness for everyone who believes. The law was given to man to show that the wrong things people do *are against* God's will. Moses described righteousness with the law and taught man that he should obey the law so that he could live. The law continued to be the schoolmaster until Christ came. The law showed man the errors of his ways and his need for salvation. While the law was good in teaching man righteousness, it didn't have the power to forgive, save and give us power to fulfill it, so Christ came to do what it couldn't do. Paul says, "Don't ask questions like, 'Who will go up to heaven?' or 'Who will go down into the world below?' Righteousness is obtained by faith and the Word is near you now, all you have to do is confess it with your mouth and believe it in your heart. This is what we have been preaching to you. All you have to do is receive it." The Good News is Jesus Christ, believe it and receive it!

Romans 10:9-13 *NCV*

If you have joined a church, how serious were you when you accepted the right-hand of fellowship the Pastor extended to you to be accepted into the body of Christ? Did you with your heart accept Romans 10:9-10? "***That if you shall confess with your mouth the Lord Jesus, and shall believe in your heart that God hath raised him from the dead, you shall be saved. ¹⁰For with the heart man believes to righteousness; and with the mouth confession is made to salvation.***" Salvation is God's free gift to man. All he has to do is believe it and receive it. The gospel is plain and simple. Have you ever seen something so easy that you

figured there must be a catch to it? Sometimes we say things like this are too good to be true. In this case, it is true and genuine. Perhaps this is the confusion that led the Jews to resist the gospel. Jesus became the sacrificial lamb that paid our sin debt. With your **mouth** you confess and with your **heart** you **believe** that God has raised the Lord Jesus from the dead and you are saved. How simple can it be? No animals to sacrifice. No rituals and ceremonies. By faith righteousness is obtained. You acknowledge with your mouth and you believe in your heart that God raised Jesus from the dead and you are saved. This is the stone that Israel is stumbling over.

Verses 11-13 read, "*For the scripture says, 'Whosoever believes on Him shall not be ashamed. [12]For there is no difference between the Jew and the Greek: for the same Lord over all is rich to all that call upon Him. [13]For whosoever shall call upon the name of the Lord shall be saved.*" Whoever believes in Him is not ashamed to share the Good News that he has been redeemed. He doesn't mind telling others he is saved. I thank God that the way to Christ is not a caste system, not a denomination system. It doesn't matter if you are Jew, Arab, Chinese, Vietnamese, African, Haitian, American, or whatever; there is no difference between us. We are all equal in God's sight and come to Him the same way. You can be the CEO of a company or a criminal sitting in jail, Christ receives both the same way. He said whoever believes on Him. If you are a prisoner, while the law might condemn you and say "You are guilty," Christ will forgive you and say "Your sins are forgiven." You may still have to do the time, but you will experience a newness of life that you've never felt before. From behind the bars, you will experience a freedom that is beyond what the human mind can comprehend. Jesus Christ is the only one who can give you that. This is why He says, "*Peace I give to you, not as the world gives I give to you. Let not your heart be trouble, neither let it be afraid.*"

Romans 10:14-17 *Dake KJV*

Paul continues in verses 14-17, "*How then shall they call on him in whom they have not believed? And how shall they believe in him of whom they have not heard? And how shall they hear without a preacher? [15]And how shall they preach, except they be sent? As it is written, how beautiful are the feet of them that preach the gospel of peace, and bring glad tidings of good things! [16]But they have not all obeyed the gospel. For Isaiah says, 'Lord, who has believed our report?' [17]So then faith comes by hearing, and hearing by the Word of God.*" How can one call on the Lord Jesus Christ if they've never heard of Him? How can one believe in Him if they've never heard of Him? Your first exposure to the gospel was from a

preacher. It may have been from radio, television, recordings, church, on a street corner, or home but it was from a preacher. Preachers are sent by God. Paul says, "*It is beautiful to see those that have accepted the call and carry the good news.*" The preacher can preach, preach and preach and wonder if anyone is listening. Isaiah must have wondered the same thing for he asked the Lord, "Who believed our message?" Even though Christ came through the nation of the Israel, not all Jews accepted the gospel message. Paul says, "Faith comes by hearing the gospel preached." The preaching of the gospel will continue until everyone has heard it. Even though all will hear it, many will turn a deaf ear to it. Eternal life is for every man that will receive the gospel by faith. Preaching is why we have former drug addicts, former prostitutes, former thieves, and redeemed sinners.

Romans 10:18-21 *Dake KJV*

Verses 18-21 continue, "***But I say, have they not heard? Yes verily, their sound went into all the earth, and their words unto the ends of the world. ¹⁹But I say, did not Israel know? First Moses says, I will provoke you to jealousy by them that are not my people, and by a foolish nation I will anger you. ²⁰But Isaiah is very bold, and says, I was found of them that sought me not; I was made manifest unto them that asked not after me. ²¹But to Israel he says, All day long I have stretched forth my hands unto a disobedient and gainsaying people.***" Paul uses an interesting way of teaching in his letter. He introduced an argument to provoke people to think. To the question, "***Have they heard?***" He says, "*Yes, preaching went from one end of the earth to the other.* **Did Israel know?** *They knew and it is inexcusable that they reject the gospel. Moses preached to them when they made God jealous and angry over their worship of false gods and said He would provoke them to jealousy and make them angry by choosing people who were not His chosen ones. The prophet Isaiah also boldly prophesied the same thing, that the Lord would put salvation in the reach of the Gentiles who were not seeking it and knew nothing about it, but would receive it. But Israel he said, 'All day I have stood ready to accept these disobedient and stubborn people.'* God has found His way into the hearts of men around the world. People of every nation, all over the world have accepted the God of Israel as their God. While the nation of Israel is His chosen people, Gentiles were always a part of the plan. This is revealed in the promise He made to Abraham that all nations would be blessed.

When Adam did that one act of disobedience that caused all mankind to sin, Jesus came and did one act of obedience that gave each of us an opportunity to regain what Satan took from us. The Holy Bible is God's instructions on how to do this. There was a television show called "Survival". In this series people are stranded on an island and have to seek ways

to survive until they are rescued. Life's journey on earth is like this. The difference is God didn't leave it for us to figure out ourselves, He gave us instructions. When God created man He created him to live eternally. However, when Satan tricked Adam and Eve into disobeying God, they lost eternal life. Genesis 3:8 tells us that when God came through the Garden in the cool of the evening, they were hiding from Him. That was because they could no longer fellowship with God in the way that they previously had because when they sinned they immediately died spiritually. We know, too that they eventually died the physical death. That one sinful act of Adam caused all mankind to die, but God had a plan that would give us an opportunity to take back what Satan stole. The plan is in His book, the Holy Bible. Who will be wise enough to follow the plan? Who is willing by faith to accept the gospel of Jesus Christ? Who will grab the opportunity to fellowship with God again? Who will follow the plan in order to recapture eternal life? Satan's job is to steal, kill and destroy. He does everything he can to destroy the credibility of the Church, of the Preacher, of the plan that God gave to us for salvation? He will do everything he can to destroy you, too, because he doesn't like you either. Who will be wise enough to see his trickery? Who will learn to stand against the wiles of the devil? Who will follow the Lord's plan?

Everything negative was born when Adam and Eve disobeyed God; lying, cheating, hate, abuse, addictions, fighting, disharmony, dysfunctional families, etc. Blame was born. Adam blamed God for giving him Eve, and Eve blamed the serpent for tricking her. The blame game goes on. We all blame somebody for something. Some blame others for the reason they won't received the gospel. They lump all the preachers together and blame the preachers or they get mad at one Church and blame all the Churches, etc., but I ask you, "Whose soul is at stake?" The Apostle Paul tells us to work out our own salvation with fear and trembling (*Philippians 2:12*). The same evil force that was in the Garden to steal Adam's soul is still around seeking to steal ours, but he is powerless over one that has received the Gospel. Are you one of them? ***Seek the Lord while He may be found, Call upon Him while He is near.*** " (Isaiah 55:6)

Quiz -- Romans 10

Select the best answer.

1. What was Paul's burden for his Jewish brothers?
 a. That they have knowledge
 b. That they have zeal
 c. That they be saved
 d. That they submit to God's righteousness
 e. Both c and d

2. Why did God give the law to man?
 a. To teach man which things are right and which are wrong
 b. To control man's mind and make him obedient
 c. To be a stronghold on his life
 d. All of the above

3. What were the limitations of the law?
 a. It could not give man the desire to do the right thing
 b. It could not change a man's heart
 c. It didn't have the power to forgive
 d. All of the above.

4. What specific verse in Romans 10 tells man how to be saved?
 a. Verse 3
 b. Verse 9
 c. Verse 11
 d. Verse 14

5. What did God do to compel men to believe?
 a. He sent the preacher
 b. He sent Esaias
 c. He sent the overseer
 d. He sent the deacon

ROMANS 11

DON'T TAKE IT FOR GRANTED!

If you've studied the biblical history of Israel you were able to see how unbelief and rebellion can harm us. We've learn that God demanded obedience from His chosen people. There were times they would venture off and worship the idols of other nations. Whenever they did, they suffered the consequences. Why is it so hard for us to believe that God can use things like 9/ll, hurricane Katrina, the wild fires in California, hurricanes and tornadoes that have swept over our land in this decade to discipline us? When He withdraws His arms of protection from around us we are left vulnerable to the enemy and are attacked by terrorists, catastrophes, etc. He chastised Israel many times because of their lack of respect and disobedience. Paul said that the wrath of God is against all ungodliness and unrighteousness. (Romans 1:18) God is not a respecter of persons and demands the same obedience from Jews and Non-Jews. If God didn't tolerate Israel's sin, why would He tolerate the sins of His chosen children, why would he accept the sins of those who were grafted in?

Romans 11:1-6 *GNB*

The Apostle Paul began Romans 11 with a question, *"I ask, then: Did God reject his own people? Certainly not! I myself am an Israelite, a descendant of Abraham, a member of the tribe of Benjamin. ²God has not rejected his people, whom he chose from the beginning. You know what the scripture says in the passage where Elijah pleads with God against Israel: ³'Lord, they have killed your prophets and torn down your altars; I am the only one left, and they are trying to kill me.' ⁴What answer did God give him? "I have kept for myself seven thousand men who have not worshipped the false god Baal." ⁵It is the same way now: there is a small number left of those whom God has chosen because of his grace. ⁶His choice is based on His grace, not on what they have done. For if God's choice were based on what people do,*

then his grace would not be real grace. In writing the epistle of Romans, the Apostle referred to Old Testament prophets and reminded them "God has not forgotten Israel." Elijah made intercession for them when they killed the prophets and when he thought he was the only one left, God told him that He had reserved to Himself 7,000 men who did not bowed to the idol Baal. Paul tells them, even today, he has reserved a remnant elected by grace (God's unmerited favor)), not by works. God in His omniscience see what man can't see. He has a birds-eye view of all that He created. He saw the prayers of the righteous during the catastrophic events of America. There were many lives lost, but even more saved. It is grace or unmerited favor at work.

When you see a man raised up by God from drugs, alcohol or some form of wretchedness, God is showing the benefits of grace. It isn't anything the person deserves, but he gives it to him. GRACE

Romans 11:7-12 *GNB*

⁷ What then? The people of Israel did not find what they were looking for. It was only the small group that God chose who found it; the rest grew deaf to God's call. ⁸As the scripture says, "God made their minds and hearts dull; to this very day they cannot see or hear." ⁹And David says, "May they be caught and trapped at their feasts; may they fall, may they be punished! ¹⁰May their eyes be blinded so that they cannot see; and make them bend under their troubles at all times." I ask, then: When the Jews stumbled, did they fall to their ruin? ¹¹By no means! Because they sinned, salvation has come to the Gentiles, to make the Jews jealous of them. ¹²The sin of the Jews brought rich blessings to the world and their spiritual poverty brought rich blessings to the Gentiles. ¹³Then, how much greater the blessings will be when the complete number of Jews is included!" God gave Israel everything they needed. He told them "*I will bless those that bless you and punished those that hurt you.*" He was their God. He gave them the prophets to hear. All they had to do was believe, trust and obey the Word He gave to the prophets, but their history tells us that they had a habit of looking for what they wanted in all the wrong places. They were always looking for something tangible, and everything they found was false, superficial, and not genuine. This left them in poverty spiritually. Therefore, God gave them a spirit of slumber as Paul again refers to Old Testament scripture in a Psalm of David, to make his point. With their eyes wide open, they were blind. Even when they were listening, they couldn't hear. The truth eluded them and their own table of providential blessings has become a snare or a stumbling block to them and a means of punishment to them." Through their stumbling, salvation has come to the

gentiles to make them jealous. Their failure to accept the gospel brought rich blessings to the world and left them in spiritual poverty. But just think how great those blessings will be when the complete number of Jews is included. God has not forgotten Israel.

Romans 11:13 – 15 *GNB*

In verses 13 through 15, Paul directs his attention to the Gentiles or non-Jews. "*I am speaking now to you Gentiles: As long as I am an apostle to the Gentiles, I will take pride in my work. [14]Perhaps I can make the people of my own race jealous, and so be able to save some of them. [15]For when they were rejected, mankind was changed from God's enemies into his friends. What will it be, then, when they are accepted? It will be life for the dead!" [16]If the first piece of bread is given to God, then the whole loaf is his also; and if the roots of a tree are offered to God, the branches are his also.* Paul, God's chosen vessel, an apostle to the Gentiles, took pride in his calling. While he was called to be an apostle to the Gentiles, he always had the interest of his people, the Jews, at heart. He talks about the mistake they made rejecting the gospel and God as a result rejecting them and accepting the rest of the world as His friends. Paul says, "Just imagine what it will be like when they are accepted, all can rejoice because it will be like seeing them raised from the dead."

Romans 11:17-24 *GNB*

Paul warned the Gentiles not to take their salvation for granted. He compared Israel to a cultivated Olive tree and the Gentiles to a wild one. Verses 17 & 18 read, "*Some of the branches of the cultivated olive tree have been broken off, and a branch of a wild olive tree has been joined to it. You Gentiles are like that wild olive tree, and now you share the strong spiritual life of the Jews. [18]So then, you must not despise those who were broken off like branches. How can you be proud? You are just a branch; you don't support the roots—the roots support you*." Israel here is referred to as a cultivated (prepared for use) olive tree. The branches broken off the cultivated olive tree are symbolic of the Jews who rejected God's plan of salvation. The Gentiles (non-Jews accepting the Gospel) are referred to as a wild olive tree, a branch that has been grafted in to replace the branches broken off the cultivated tree (Israel). Paul instructs the Gentiles, "*You share the spiritual things of God with them, but be careful, "Don't be so proud of yourself that you forget and despise the branches that were broken off. Remember, that you're just a branch. You don't support the root, the root supports you.*"

Romans 11:19-24 *GNB*

19-But you will say, "Yes, but the branches were broken off to make room for me." 20-That is true. They were broken off because they did not believe, while you remain in place because you do believe. But do not be proud of it; instead be afraid. 21-God did not spare the Jews, who are like natural branches; do you think he will spare you? 22-Here we see how kind and how severe God is. He is severe towards those who have fallen, but kind to you—if you continue in his kindness. But if you do not, you too will be broken off. 23-And if the Jews abandon their unbelief, they will be put back in the place where they were; for God is able to do that. 24-You Gentiles are like the branch of the wild olive tree that is broken off and the, contrary to nature, is joined to a cultivated olive tree. The Jews are like the cultivated tree; and it will be much easier for God to join these broken-off branches to their own tree again. You may say the Jews were broken off that you might be grafted in, but remember that was because of their unbelief. You will stand by *faith*, so don't be high-minded, but fear God. If He didn't spared the Jews, He won't spare you either. Look at both his goodness and His seriousness. If God promises to cut off those who do not remain in His goodness, He will do just that. He is not a liar. If you continue in His goodness, he said, you will be rewarded with goodness. If a Jew's heart change and he then believes, he can be grafted in again. Isn't it more natural for branches that fall away from a tree to be grafted back in than it is for a branch from a wild olive tree to be grafted into it? Don't be fooled that once you are grafted in that you can't be broken off." This clarifies the point he made earlier, just as the hearts and minds of the Jews became dull, so can ours. God is not a respecter of persons. He requires obedience from all.

Romans 11:25-27 *GNB*

Verses 25-27 read, "*There is a secret truth, my brothers, which I want you to know, for it will keep you from thinking how wise you are. It is that the stubbornness of the people of Israel is not permanent, but will last only until the complete number of Gentiles comes to God. [26]And this is how all Israel will be saved. As the scripture says, "The Savior will come from Zion and remove all wickedness from the descendants of Jacob. [27]I will make this covenant with them when I take away their sins.*" In these Verses the Apostle Paul talks about the future salvation of Israel and reminds them of the prophecies of Isaiah. The word *secret* is synonymous with the word mystery found in the KJV. Here Paul tells them, "I don't want you to be ignorant of this mystery and become vain in your relationship with the Lord like

Israel. This is why they are in part blinded until the Gentile reign of Jerusalem ends. At that time the whole nation that is alive in Palestine will be saved according to the scriptures. The Savior will come from Jerusalem and take away all evil from the family of Jacob as Isaiah prophesied in Chapter 27:9. He will deliver them and turn them away from ungodliness and fulfill His agreement with them.

Verse 28 and 29 read, "**Because they reject the Good News, the Jews are God's enemies for the sake of you Gentiles. But because of God's choice, they are his friends because of their ancestors. 29-For God does not change His mind about whom he chooses and blesses.**" Israel is referred to as being enemies to the gospel, but Paul reminds the Gentiles that God chose them and they are his beloved because of the covenant He made with their ancestors (Abraham, Isaac, Jacob). Verse 29 in the KJV says, "The gifts and callings of God are without repentance." This not only refers to the gifts and callings of Israel, but to any individual whom God calls or gives a gift to. God does not change His mind as if He made a mistake. Men may fail Him so that He cannot fulfill such callings with them, but when, if ever, they come back to repentance God holds them to the original obligation to obey Him.

Sometimes we don't understand what real grace is apart from what we are capable of doing with and without God's help. It isn't until He backs away from us and we are stumbling around in darkness that we exhaust ourselves and ask for His help that we learn what grace really is. Many are searching, but haven't found the answer because they are looking for something tangible, or an instamatic solution. They hear the truth preached, but won't accept it because it can't be that easy or it's too hard, or its taboo, or it won't work, or nobody else is doing it, etc. Paul cautioned the non-Jews (Gentiles) not to be high-minded, but to remember that you stand by faith. We must remember that even today. How much of life do you take for granted? Do you take it for granted that you are in a country with freedom of speech? Do you take it for granted that you can choose what you want to listen to? Let us not be deaf to God's call. God uses our own stubbornness to give us a reality check that will help us see and understand that apart from Him we are nothing. He challenges us in order to drive us to Him not away from Him.

Romans 11:30–36 *NCV*

30-At one time you refused to obey God. But now you have received mercy, because those people refused to obey. 31-And now the Jews refuse to obey, because God showed mercy to you. But this happened so that they also can receive mercy from him. 32-God has given all people over to their stubborn ways so that he can show mercy to all. 33-Yes, God's riches are very great, and

his wisdom and knowledge have no end! No one can explain the things God decides or understand his ways. 34-As the Scripture says, "Who has known the mind of the Lord, or who has been able to give him advice?" 35-"No one has ever given God anything that he must pay back." 36-Yes, God made all things, and everything continues through him and for him. To him be the glory forever! Amen. The non-Jews in times past didn't believe God, but now have obtained mercy through Israel's unbelief. God has shown His mercy to the Gentiles (Non-Jews) to provoke Israel's jealousy, but He will again show His great mercy to the Jews. Isn't it amazing that Non-Jewish people have believed and received the gospel that God gave to the Jews first, but they rejected. There was a time when the Gentiles didn't believe God, but God showed them mercy. That was always a part of the plan anyway, that men of every nation be blessed. It was the promise that He made to Abraham (Genesis 12:3). In Verse 34, Paul expresses awe in this great God, "Is there anyone that knows what He knows or that can give Him advice? No one has ever loaned him anything and that He had to pay back. That is because everything belongs to Him already. He created and controls everything that exists. Let Him be glorified forever. He is worthy of honor and majesty. Every man should praise Him. Amen.

Relevance to Today

Do you think that verses 7-12 apply only to Israel? I heard one preacher cast disdain on God's spiritual blessings and referring to them as the *"pie in the sky."* He had made it clear with his prosperity preaching that he was more focused on what he could see and have now. Many are more consumed with prosperity, material things and don't want to pursue and wait for God's spiritual blessings, because they don't trust what they can't see. Too many hearts and minds have become dull and insensitive to sound doctrinal preaching. People hear, but they don't understand. They see, but they can't visualize God's blessings. They move from church to church looking for someone to turn them on to the gospel or a church that is perfect. Some complain endlessly and prevent themselves from grasping the righteousness of God. Instead they go about trying to establish their own righteousness and only make fools of themselves.

God is creator of everything. He and He alone know the purpose for which He created things. He gave the Holy Scriptures which are a like a road map for us to follow. The quicker we learn our true destiny when we follow it and the better we live our lives. Many didn't know at the onset of their calling that they would be preachers, teachers, presidents, politicians, tele-evangelist, prison ministers, or even martyrs for the sake of the gospel, but being driven by their passion and love for the gospel of Jesus Christ they embarked on a journey that took them to their true destiny.

Quiz -- Romans 11

Select the best answer.

1. The Apostle Paul used Old Testament scripture to explain IN Romans 11
 a. How easy it is to be lost
 b. How the prophets were killed
 c. That it is a mistake to worship Baal
 d. Why God had not given up on Israel

2. Some Jews will believe and be a part of a remnant saved according to the election of
 a. Paul
 b. Peace
 c. Grace
 d. Unspeakable joy

3. _____ gave the unbelieving Jews the spirit of slumber unto this day.
 a. Apostle Paul
 b. Laziness
 c. Ignorance
 d. God

4. Who prayed that their table of providential blessings become a snare and trap, a stumbling block to them?
 a. David
 b. Apostle Paul
 c. God
 d. Lazarus

5. Through Israel's failure to accept the gospel, they stumble and salvation came to the
 a. Poor
 b. Gentiles
 c. Wicked
 d. Wise men

ROMANS 12

A LIVING SACRIFICE

Points Covered

- Give your body as a living sacrifice.
- Do not conform or adapt to the world around you, but be transformed or changed by the renewing of your mind.
- God has given every man faith, gift(s) and a function in the body of Christ.
- The saints of God are to live a life of holiness before each other and the world.

In the epistle of Romans, Chapters 1 through 11, Paul taught the church in Rome how to receive salvation and now in Chapters 12 – 16, he teaches the saints how to live a life of holiness. This is our reasonable service.

Discussion: Identify and discuss specific changes that have come into your life since you accepted Christ as your Savior and Lord.

Are You a Living Sacrifice?

If you consider the price that Jesus Christ paid for our sins, it was the ultimate sacrifice and only He could pay. There is nothing that can supercede what He did. Isaiah 53:3 said *"He is despised and rejected of men..."* That prophecy was fulfilled about 800 years later. He was so despised by man that they whipped Him, spate on Him, and did everything they could to belittle Him. They rejected Jesus, the Savior of the world and then they crucified Him or did they? Could they really kill Him? What did He mean "You don't take my life, I lay it down." Before He died on the cross He said, "Father, forgive them for they know not what they do." He was the only unblemished lamb that

could pay our sin debt. This was a divine process that only God could give. How much is that sacrifice worth to you? The Apostle Paul teaches what the perfect will of God is in Romans chapter 12.

Romans 12:1 *The Dake KJV*

"*I beseech you therefore, brethren, by the mercies of God, that you present your bodies a living sacrifice, holy, acceptable to God, which is your reasonable service.* In other words the Apostle Paul is saying, "I beg you, brothers and sisters, with the love of God, that you make your bodies an offering that is holy (*The word holy means pure, sinless, sacred, or set apart*) and acceptable to God which is reasonable service." If you have come to Christ already stop, think about it, and ask yourself "*What kind of offering am I? Have I made my body an offering that is holy and acceptable to God?* Paul uses the word "reasonable" to describe our sacrificial service. It means just, fair, sensible, wise, or not excessive. God has not placed any excessive demands on us, yet Satan would have us think that He requires too much of us. He simply instructed us to dedicate our lives HOLY to Him for service. In other words, instead of living our lives haphazardly, reckless, and wicked, we are to learn to live them in a way that honors God. While we are a work in progress, we should be reaching for the mark of the high calling. We should be progressing or moving in a forward direction.

Our daily lives are mirrors of who we are and whether we are a living sacrifice, a testimony, a vessel used by God or not. They are outward expressions of what's on the inside of us. When it comes to the things of God, how would you answer these questions? Are you observing His commandments to love as He instructed us to love? What kind of relationship do you have with Him? Are you in a relationship with someone that's NOT pleasing to Him? When you turn your radio or television on, do you ever stop on the Christian stations or do you always go past them? Do you sit in front of a television endless hours (watching ESPN, sports, etc.) and never spend any time reading and studying your Bible. Do you spend all day on the golf or tennis course and then limit how long you will sit in a worship service? Do you go to your favorite places numerous times a week or month, but complain about how many times you are ask to show up to church? Do you go out of your way to get your children to little league or cheerleading practice, but won't spend any time getting them ready for Sunday school? Do you commit to working the concession stands for their games, but won't commit to mission work at church? These things do not define you as a Christian, but they say whether you are carnal-minded or spiritual-minded. They say something about where you've placed God in your life. Idols are not just images

carved out of stone or wood. Do you have any idols? An idol is anything that you spend more time with than you do God. What about your finances do you spend time gambling it away at casinos or playing lottery and complain when it is time to give to the Lord? Is it easy for you to get into an argument or a fist fight when you get angry or do you try to do what is pleasing in God's sight? Is it easy for you to curse someone out but hard for you to pray for them? Is it hard for you to forgive your debtors? Do you care more about what man thinks of you than you do God? *"What kind of offering are you?"* A sincere prayer of David's was Psalm 139:23-24, *"**Search me, O God, and know my heart: try me, and know my thoughts: 24-And see if there be any wicked way in me, and lead me in the way everlasting.**"*

Romans 12:2 *The Dake KJV*

[2] *"**And do not be conformed to this world, but be transformed by the renewing of your mind, that you may prove what is that good and acceptable and perfect will of God.**"* The Church is a body of baptized believers who are to fulfill the great commission (St. Matthew 28:19-20), to be more than members, but Jesus disciples. In order to become disciples we must **not** allow our lives to be shaped or patterned by the world around us. Our change begins with a renewed mind. God gave us the Word of truth that we may be a kind of first fruit of all that He created, that is, believers should be set apart for His glory. If we take to heart the gospel that is preached and we study the Word with sincerity, our minds are reprogrammed to have the mind of Christ. When we apply it to our lives we can prove that God's will and way is perfect. Satan has a lot of people fooled today. He is still telling lies the way that he did to Eve in the Garden of Eden and a lot of us are buying into them. *"This is a new generation or era, the Bible is not relevant to us today,"* *"You are human, and can't live a life of chastity."* Romans 1:25 tells us that God does not like it when we change His truth into a lie. If we rewrite the Holy Scripture or interpret it to satisfy the lust of our flesh we're lying on God. We must not follow the ones that are doing it. This is why it is important that we get to know the Bible. Hebrews 13:8 says, *"**Jesus Christ, the same yesterday, today, and forever.**"* God's Word will stand and will not change. Through Jesus Christ, we are more than conquerors. The same way that the Apostle Paul, John Wesley, Phoebe Palmer and others said, *"We can live holy"*, we too are to say "Yes we can!" If Christ is in us, *"**Greater is he that is in us than he that is in the world.**"* Christ is greater than the devil so we should not be saying *"The devil made me do it."* God does not entice us with evil. We are enticed and drawn away by our own evil desires and they give birth to sin.

If you were to describe yourself as a living sacrifice, what would you say? What are you doing to prove that His way is good, acceptable and His will perfect? God hasn't instructed us to do anything that He hasn't given us what we need to work with. By the power of authority that He has as Creator, He has every right to demand that we present our bodies as a living sacrifice. Jesus paid the price, sent us the power of the Holy Ghost to help us and gave us the Holy Scriptures to cleanse us.

The Apostle Paul told his brethren to "Be changed by the renewing of your mind." The worldly mind that you had when you first came to Christ, let it be made new by accepting God's will for you. We have a tendency to feel comfort in numbers and conform to the world or things around us, but that is dangerous because broad is the way that leads to destruction (Matthew 7:13). If we are going to please God, we have to dare to be different. There is a saying we often hear, "*Birds of a feather flock together*". In other words people will judge you by the group they see you hang with. Make sure that you are set apart so that we can prove what is holy and acceptable to God. There are times when we must separate ourselves from worldly things so that we don't destroy the credibility of our witness. II Corinthians 6:17 reads, "**For which cause, Come out from among them, and be separate, says the Lord…**" It is the only way that we can prove the perfect will of God. There are a lot of things going on in our society today that are contrary to the word of God. It is our reasonable service to take a stand for righteousness and not conform to the world around us. We cannot prove and fulfill the perfect will of God if we care more about what people think of us than we do God. Your friend might say you are "good for nothing", but God says you are fearfully and wonderfully made. Who do you believe?

When we accept Jesus as our personal savior, we are not to come with our own agenda and place it down before Him to accept. It is alright to "Come as you are", but come anticipating change in your life. We must come humbly, acknowledging our own sinfulness and in true repentance to Him. You are then converted or born again. After David sinned with Bathsheba and repented, he said in Psalm 51:16-17, "**16For you desire not sacrifice; else would I give it: you delight not in burnt offering. 17The sacrifices of God are a broken spirit: a broken and a contrite heart, O God, you will not despise.** In other words *true repentance* is the sacrifice that God wants, not a burnt offering, animal sacrifice or ritual. A sincere heart, a heart of repentance of our sins is what He wants from us and we experience change in our lives. You are then a work in progress, you've given your body is a living sacrifice, to be holy and acceptable to God. Our way of thinking changes and so do our conduct. Jesus liberates us from the sin that dwells in us. (Ref. – Romans 7:20) He liberates us from those things that have held us in captivity or bondage or sins that we feel controlled our lives. This is why you hear Christians say. "*The things that I used to do, I don't do any more.*" "*The things*

that I use to say, I don't say any more." "The places that I used to go, I don't go any more." This is what Tramaine Hawkins meant when she sang, *"A Wonderful Change Has Come Over Me."*

The Apostle Paul in I Cor. 15:31 used this phrase *"I die daily..."* I am able to identify with that, because I've learn the importance of submitting my will to God's will. When He shows me things in my character that is not like Him, I know that I must submit to His righteousness not my own. I don't always want to, but I'm willing to because that is what keeps me connected to Him. He keeps me free of idols, meaningless rituals, and helps me to be honest and sincere in my heart and mind. In the same way that God referred to David as a man after His own heart, I want Him to say that I'm a woman after His own heart. I know that it is not what I do that saves me (Eph. 2:9), but what I do or don't do witnesses to the world the product I've become.

In Romans Chapter seven, Paul shared his own personal experience of how he wrestled with sin and in Romans 7:21, he described it like this, *"I found that when I want to do good evil is present with me."* He described himself when he was in bondage to sin in verse 24 as *"A wretched man I was! Who will deliver me from this body of death?"* A wretch is an unhappy or miserable person. But in verse 25 he revealed the answer, *"I thank God—through Jesus Christ our Lord! So then, with the mind I myself serve the law of God, but with the flesh the law of sin.* Romans 8:1--*There is therefore now no condemnation to those who are in Christ Jesus, who do not walk according to the flesh, but according to the Spirit."* In other words, Paul is saying, I learned that if I let the mind of Christ rule and I walk according to the Spirit, I can serve God, but if I let the lust of my flesh control me, I serve the law of sin. This is why we need renewed minds. If you have a mind to serve God, if you have a mind do what is pleasing to Him, give it charge over the flesh and with the help of the Holy Spirit you will serve God. This is the way to sanctification. If you have a mind that is in the gutter, your flesh will follow it. If you have a mind that is full of unrighteous clutter, your body will follow it. If you have a mind that is idle, an idle mind is the devil's workshop. If you have the mind of Christ, you body will follow it. You will be able to do those things that are pleasing in His sight and your body will become a willing and living sacrifice to God.

I know what the devil will do to your mind. I remember when I spent a lot of time rehearsing my hurts, or nursing old wounds. I call it *singing the blues*. As long as I nursed my wounds, my pain and my problems never went away. My wounds never healed and I never got better. The Holy Spirit showed me that I couldn't go forward always looking back. Rehearsing old hurts is like playing a cassette player/recorder in your brain. You have the buttons for forward, rewind, play, stop, and record. Every morning, the devil would press the play button and I would wallow in all my past hurts, negative thoughts, and fears and then he would press rewind so I could hear the same stuff over and over again. One

theologian said that, "Man *doesn't really get to know God until he has exhausted himself.*" It exhausted me and I said, "*Devil you are a liar, I will not live my life this way*". I realized what Jesus meant when he said, "*Resist the devil and He will flee from you.*"

Before long I was cleaning and doing things about the house and I realized that I wasn't wallowing in self-pity any more. I had pressed the stop button. No one else could do it for me. The Holy Spirit didn't. The devil wouldn't because it is his job to steal your mind, your peace, your happiness, etc. He wants you on Prozac. When the Holy Spirit showed me that I couldn't go forward looking back, he was showing me then that it was I who had to press stop. He had given me the power. All I had to do was use it and submit my will to His will, "…not my will, Lord, but your will be done."

If we keep ourselves from becoming polluted by the world and allow our minds to be renewed, we can show to the world "what is that good, acceptable, and perfect will of God." We can present our bodies as living sacrifices, holy, and acceptable to Him.

David had faith in God as a young boy. By his faith in God, he defeated the giant, Goliath, but I don't believe that David got to know God in the most intimate way until he had gone through persecution and hardships and committed a horrible sin for which he thought there should be no forgiveness. He had committed adultery with Bathsheba and impregnated her. David labored to cover up his sin, but couldn't and resorted to having her husband, Uriah, killed. When the prophet, Nathan, described this despicable act in a parable to him and said, "David, that man is you." When David took a look in the mirror, he wanted to die, but God forgave him for his sins. But He didn't let him off the hook that easy for he was told the sword would never depart from his house. Read the whole story for more information on David. When David had exhausted himself, he was able to empty himself before God and trust in the only One that could give him comfort and strength. God purified and refined his character and he went on to build the nation of Israel into a strong one. If you read the Psalms of David, you will see that he learned how to trust God even more and understood that He was the only one with the power to forgive him for his sins. He was happy when God forgave him. (Psalms 32:1)

Romans 12:3-5 *Dake KJV*

"*For I say through the grace given to me, to everyone who is among you, not to think of himself more highly than he ought to think, but to think soberly, as God has dealt to each one a measure of faith. ⁴For as we have many members in one body, but all the members do not have the same function ⁵so we, being many are one body in Christ, and individually*

members of one another. Here Paul is saying it is not fitting for you to put yourself on a pedestal. Don't think of yourselves more highly than you ought to. God has given to every man a measure of faith so think soberly and try to understand that each one has a role that is important. There are many members in the body of Christ. They do not have the same function, but they are all important. While there are many of us in the body of Christ, we are one body and all of us are members of that body. We need each other. Gifts are given to us according to His grace and we can show honor to Him by appreciating and using them to the best of our ability. The Clergy have the responsibility of equipping the saints to serve. Members have the responsibility of serving by going out and making more disciples. We work together and as we work together, we discover that we have gifts we didn't know we have and we use them for the glory of God. If you're not sure what your gifts are, you can learn what they are by making yourselves useful in the body of Christ. Get involved in your Church's outreach ministries and activities. If your Church doesn't have an outreach ministry, it may be an opportunity for you to organize one, such as a prison, a nursing home, or youth ministry. It can work to your advantage if you belong to a small or newly developing Church because everyone is needed for something. I volunteered to teach the youth Sunday school class in my Church. I don't think that I would have had that opportunity had I joined a large well-established Church. That opportunity contributed much to my knowledge of the Bible and to my Christian growth.

Romans 12:6-11 *NKJV*

Listen to verses 6-8 from the Good News Bible, Paul here begins talking about spiritual gifts. It reads *⁶Having then gifts differing according to the grace that is given to us, whether prophecy, let us prophesy according to the proportion of faith; ⁷Or ministry, let us wait on our ministering; he who teaches, in teaching; ⁸he who exhorts, in exhortation; he that gives, with liberality; he who leads, with diligence; he who shows mercy, with cheerfulness."* Every member has a gift or gifts. Some have the gift of *prophesying* or preaching and some don't, but whatever gifts they have they are important to the Church. If it is to *minister* or serve, then do it with gladness of heart. If it is to *teach*, then do it. Some have a gift of *exhortation* or encouraging others and that is very important in the body of Christ. If you have the gift of *leadership*, you have the power to influence change and spearhead projects. You may be in a lead position under your Pastor as the chairman or coordinator of a committee or group in a Church. Lead with diligence and have a passion for what you are doing. Some have the gift of *giving*. We call them *free-hearted* and sometimes we say they will give you

the shirt off their back. They have the gift of giving. God loves a cheerful giver, and when they have this gift, they give freely. Some have the gift of *mercy*. They enjoy visiting the sick and helping feed the poor, etc. They get satisfaction from helping people. They won't kick a person when he's down, but will lend a helping hand in helping him to rise above his circumstances. All of these gifts are important to the building up of the Church.

Listen to what Hebrews 5:12–14 NCV says about spiritual maturity. "**By now you should be teachers, but you need someone to teach you again the first lessons of God's message. You still need the teaching that is like milk. You are not ready for solid food. ^{13}Anyone who lives on milk is still a baby and knows nothing about right teaching. ^{14}But solid food is for those who are grown up...**" *Milk feeding* was a metaphor used by many writers to express the first principles of religion and science. If you search the scriptures, you'll see this metaphor many places. Be concern about your own Christian growth and development. Study and seek to know God through His Word of truth that you might mature in the faith. Don't despise humble beginnings like teaching a group of 4 or 5 year olds or a youth class. We learn by teaching. It is an opportunity to grow, practice and be prepared for what comes next. While you are waiting on directions for your ministry, you are being prepared for it. The scripture "...wait on your ministry...teaching" does not mean to sit idle. It means rather don't rush off to an assignment for which you have not been prepared. If the Lord calls you to preach today, it does not mean that you are ready to pastor a church. To be a good leader, you must first be a good follower. If you are not studied, you are not ready to preach. Don't go where you haven't been sent.

Today's Application

Ministers who become Pastors have several gifts and even talents. A pastor has the gifts of prophesying or preaching and ministering (serving). Without those two gifts it would be hard to pastor. The word minister means to serve so don't limit it to the one called to lead a congregation. The pastor should also have the gift of leadership (ruler). Without this gift it would be difficult to shepherd a flock. He could have other gifts and talents that enhance his ministry like singing, playing an instrument, oratory skills, etc. Nevertheless, one of those gifts could be more dominant than the other. Take for instance the televangelist, Joel Olsteen. Everyone that listens to Joel knows that he has the gift of exhortation (encouraging people) and preaching, but he must have some of the other gifts that I mentioned as well since he is leading a huge flock of people. The gift of exhortation is his strongest. When Joel finishes preaching, everyone feels inspired. Another example is Cleflo Dollar. He has the gifts to lead, preach and teach. Among his strongest gifts, he has the gift of teaching

and the gift of administration. His administrative gift enabled him to build Cleflo Dollar Ministries to what it is. Within the framework of each of these ministry examples, there are others who are vital to their organization. You may never see them or hear their names, but it does not matter, God knows their names and what function he gave them.

Christian Behavior in the Body of Christ

Romans 12:9-16 *The Dake KJV*

⁹ Let love be without dissimulation. Abhor that which is evil; cleave to that which is good. ¹⁰ Be kindly affectionate one to another with brotherly love; in honour preferring one another; ¹¹ Not slothful in business; fervent in spirit; serving the Lord; ¹²Rejoicing in hope; patient in tribulation; continuing instant in prayer; ¹³ Distributing to the necessity of saints; given to hospitality. ¹⁴ Bless them which persecute you; bless, and curse not. ¹⁵ Rejoice with them that do rejoice, and weep with them that weep. ¹⁶ Be of the same mind, one toward another. Mind no high things, but condescend to men of low estate. Be not wise in your own conceits."

In verses 9-16, Paul gives the saints in the body of Christ twenty instructions regarding Christian behavior. It is good to do a self- evaluation when studying these virtues and see how well you are maturing in the faith. Again, ask yourself "What kind of living sacrifice am I?" Paul talks about judging. It is not good to judge another on matters, especially when you're failing at these things yourself. The Holy Spirit will show you yourself. This opens the door for you to humble yourself, pray and seek the face of the Lord so that He (the potter) can mold and make you into the character and likeness of Jesus. Paul says, 1) Our love for one another should be real, not phony. 2) As a Christian you should not like evil. Don't relish in the evil things you see people doing. 3) Be kind and loving to one another. 4) Prefer each others company above others. Through fellowship with each other, we learn from shared experiences that help us grow in the faith. 5) We must not be slothful in doing business, whether it is on our job, in the Church, in our home or wherever. We represent Christ. 6) Be fervent in spirit. Have a passion for what you do. 7) Serve the Lord with sincerity. 8) Let hope be joy to you. 9) Be patient in your trials. 10) Continue in prayer. Pray without ceasing. 11) Take care of the needs of the saints. Visit the sick, and help in anyway you can to meet the needs of your brothers and sisters. 12) Welcome and practice kindness to everyone. 13) Bless those that hurt you. 14) Do not curse or hurt them. 15) Be happy for those that are happy and rejoice with them. 16) Weep with them when they are in sorrow. 17) Live in harmony with one another. Strive for peace. 18) Don't be so high-minded that

you can't relate to the poor. 19) Associate with humble and godly people. 20) Don't be conceited in your own wisdom. Don't be so smart that no one can tell you anything. We learn from each other.

Christian Conduct before the World

Romans 12:17-21 *NKJV*

Paul concludes Romans 12 with Christian behavior before the world. Here he gave seven commands regulating how Christians should conduct themselves before the world. This is how it reads NKJV. *17Repay no one evil for evil. Have regard for good things in the sight of all men. 18If it is possible, as much as it depends on you, live peaceably with all men. 19Beloved, do not avenge yourselves, but rather give place to wrath; for it is written 'Vengeance is mine, I will repay,'' says the Lord. 20Therefore, if your enemy is hungry, feed him; if he is thirsty, give him a drink; for in so doing you will heap coals of fire on his head. 21Do not be overcome by evil, but overcome evil with good.''* We learn from Paul here that it is not Christian behavior for us to take revenge on the enemy. We must be careful how we appear in the sight of all men, because they will judge us by how we behave before them. As Christians we must have regard for good things and do everything in our power to keep peace with men. Strive for it, but if nothing you say and do helps the situation, then do not take revenge yourself. Let the Lord have it and remember what He said, "*Vengeance is mine.*" He will handle the situation. While you have left it in His hand to handle, He says, if your enemy is hungry, feed him; if he is thirsty, give him a drink. When you do this, it is like dumping coals of fire on his head. If you listen and follow these commands, you won't be overcome by evil, but evil will be overcome *with* your good.

There are two key things I would like to emphasize for your success as members in the body of Christ. They are: 1) be transformed by the renewing of your mind. To be transformed by the renewing of your mind means first of all accepting God's Word as it is without trying to change it to fit your situation. Accept His challenge to do the extraordinary. Ask Him for that supernatural change and trust Him to give to you. If in the process you should stumble and fall, get back up again and stand. Don't beat yourself up for your errors, but learn from them. Your errors help you understand that you are not perfect and not in a place to judge others, but to pray for them and yourself. Be fervent in your heart and spirit and remember that the change you need is a divine or supernatural change. Only God can give that. He is the only One that can make man right with Him.

Secondly, 2) once transformation by the renewing of your mind has taken place, obedience to the word of God is easy. It is then that we prove what is good, holy, and acceptable to God. These are key points that Paul was teaching the Jews who thought they could live the Law of Moses on their own strength and power. We need the help of Jesus who took the sins of the world upon Him on the cross to give us power over sin and death. All we have to do is believe.

Quiz -- Romans 12

1. What request did the Apostle Paul make of his brothers and sisters in Christ?
 a. To make their bodies a living sacrifice
 b. To witness to the Gentles
 c. To anoint their children with oil
 d. To make a burnt offering to the Lord

2. What very important instruction does Paul give in order to fulfill the above request?
 a. Go to church every Sunday
 b. Do not conform to the world
 c. Be transformed by the renewing of your mind
 d. Both b and c
 e. Both a and b

3. It is our reasonable service to
 a. Be on time to church
 b. Read our Bibles at least once a week
 c. To be committed to the Pastor
 d. Present our body holy, and acceptable to God

4. Let the worldly mind you had before you came to Christ be made new by
 a. Accepting the way of the world
 b. Singing praises to God
 c. Accepting God's will for you
 d. Upholding the laws of the land

5. When you come to Jesus, you should
 a. Lay your own agenda down before Him to accept
 b. Come on your own terms
 c. Come humbly in submission to God's will and His way
 d. None of the above

6. It is important that we **not**
 a. Be ignorant of God's righteousness

 b. Humbly submit to God's righteousness

 c. Become a new creature in Christ

 d. Be transformed by the renewing of our mind.

7. Paul advises everyone not to think more highly of himself than he should, but to

 a. Just compare yourself to others and make sure you are better

 b. Demonstrate who you are in Christ

 c. Think soberly according to the faith God has given you

 d. Both a and b

8. While we have many members in the body of Christ, we don't all have the same job, because

 a. Some people just have more talent than others.

 b. Our gifts are given in accordance to the grace that God has given us.

 c. Some people are too lazy.

 d. Some people love God more than others do.

9. The body of Christ is encouraged to mature. Those who refuse to mature is described as

 a. Needing the first lessons of God over and over again, referred to as milk-feeding

 b. Still being babes in Christ

 c. Being slothful and lazy

 d. Both a and b

 e. All of the above

10. The Apostle gave the saints 20 Christian behaviors to exemplify, one of them is

 a. Curse the devil and love the saints

 b. Take care of the needs of the saints

 c. Enjoy the things of the world but go to church weekly

 d. All of the above.

11. The Apostle gave seven behaviors for Christians to exemplify in the world. One of them is

 a. Repay no one evil for evil

 b. Don't feed the enemy if they are hungry

 c. Overcome evil with evil

 d. Both b and c

12. **True** or **False**. We are encouraged to live peaceably with all men.

ROMANS 13

BE A GOOD CITIZEN

Points Covered:

- *Christians have a responsibility to submit to human governments.*
- *Christians have a responsibility for the privileges they have been granted…*
- *Christians have a responsibility to be good neighbors.*
- *Christians are to conduct themselves righteously before God.*

Chapter 13 was the most difficult chapter for me to accept the teaching of. My ancestors were once slaves and were victims of government that for a long time legalized the way we were treated as animals instead of humans, but God did deliver us. The stain of slavery still lingers over us in a way that we victimize even ourselves. In order to understand Paul's writing here I had to look at the Jewish history of government and the period of time in which it was written. Old Testament history shows that Israel, God's chosen people rejected His leadership. He led them through judges and prophets, but Samuel's sons were abusing their positions as priests and that gave them the perfect excuse to complain and ask for an earthly king. I Samuel 8:5-7 reads, "***And said unto him, behold, thou art old, and thy sons walk not in your ways, now make us a king to judge us like all the nations…***[7]***they have rejected me, that I should not reign over them…***" They had a Theocratic government, a government ruled by God. God was their king and in that day He used prophets and judges to lead them. God sent Samuel back to them to explain the pitfalls of having an earthly king. Read I Samuel Chapter 8 to see this story. Israel asked for a king like other nations around them and God warned them before he permitted them to have earthly kings that they would be subject to oppression and from bad leadership from time. If that didn't change their minds, they would have their choice, a human government and they would have to endure. If you study Israel's history, you will see from time to time they had good kings and bad kings.

They would disobey God and worship idols and He would remove His shield of protection from around them and the enemy would conquer them and put them in bondage for years. They would cry out to God and He would hear their cry and eventually rescue them.

The writing of Romans was during a time when the Jews were under the oppression of the Roman Empire. The Roman Empire was strong for centuries and Rome was called the capital of the Gentile world. Paul was a Jew, but he was also a Roman citizen. He knew of Jewish customs and thinking and Gentile practices and his knowledge proved beneficial in teaching them both the gospel. The Gentile world was influenced by idols and idol worship was what always got Israel into trouble with God, because they would conform to the world around them.

In the New Testament, we find that even though the Jews were looking for the Messiah, they were looking for a political leader like King David. They were expecting a political leader to come and rescue them from Roman oppression. When Jesus came and announced Himself as the king of the Jews, they rejected Him. They didn't understand that Jesus agenda was not political but spiritual. He brought to them and the world the real way to be delivered from the bondage of sin and death. It would liberate not just the Jews, but the Romans and all mankind. Jesus came to rule in the hearts of mankind and when He rules there, you are no longer a bigot, liar, oppressor, etc.

In Chapter 13, Paul taught men to obey governing authorities. It was something that Jesus taught. Jesus taught men to obey governing authorities for their own benefit. This was applicable to those things that did not dishonor God. Things that dishonor God, like worshipping idols and a great example is the story of the three Hebrew boys in Daniel Chapter 3 who refused to bowed down to any other god.

Romans 13:1-7 *NKJV*

Verses 1-2 read "***Let every soul be subject to the governing authorities. For there is no authority except from God, and the authorities that exist are appointed by God. ²Therefore whoever resists the authority resists the ordinance of God and those who resist shall bring judgment upon themselves.*** We learn from this passage of scripture that we are all subject to higher powers or authorities. Paul is saying here that God is the ultimate or highest authority and was responsible for putting earthly powers in place to govern people. *³For rulers are not a terror to good works, but to evil. Do you want to be unafraid of the authority? Do that which is good, and you will have praise of the same: ⁴For he is God's minister to you for good. But if you do evil, be afraid; for he does not bear the sword in vain; for he is God's minister, an*

avenger to execute wrath on him who practices evil. ⁵Therefore you must be subject, not only because of wrath but also for conscience sake. Paul is saying, "*The ruler is God's servant to help you. He has the responsibility to punish those who do wrong. Obey the law and keep your conscience clear.*" Even though there are those who abuse their power in positions of authority, we are to respect them for our own good. Maybe you didn't like President Bush when he was president, but we had to respect him. When they televised someone throwing a shoe at him in another country when he was up speaking, we didn't like it because he was our president. Maybe you don't like President Barack Obama, but we are still to respect him if we are going to honor God's instructions. We respect our leaders also because they have the power to carry out judgment upon us according to the laws of this land. In this passage of scripture, authorities are referred to as ministers. Webster's definition of minister is a *person appointed to head a governmental department; 2-a diplomat representing his government in a foreign nation; 3-one authorized to conduct religious services in a church; pastor; to serve as a minister in a church; to give help.* Definitions 1 and 2 are the ones we are talking about here. Verses 6 and 7 continue, *⁶For because of this you also pay taxes, for they are God's ministers, attending continually to this very thing. ⁷Render therefore to all their due: taxes to whom taxes are due; customs to whom customs; fear to whom fear; honor to whom honor.*" If you are commanded to pay taxes, pay your taxes and pay customs wherever it is due. Honor those that God has established over you." Laws and governments are designed for our good and our protection. The Apostle Paul is teaching the church in Rome, Christians, to honor God by respecting the government that has rule over you. The book of Romans was written during the time the Roman government was in power. The Roman government had recently put Jesus Christ to death by crucifixion. It was known for the viciousness of its soldiers and it was not an advocate of the Christian movement so Paul admonishes them for their own safety and well-being to honor governing officials. He encouraged them to pay their taxes or customs when they are due. This is something that even Jesus taught in St. Matthew 22:21, "***Render therefore unto Caesar the things which are Caesar's; and unto God the things that are God's.***" Since you are under the rule of Caesar, pay the taxes he demands, and give to God what belongs to Him.

Romans 13:8-10 *The Dake KJV*

In Romans 13:8-10 KJV, Paul teaches Christians how to conduct themselves before their neighbors. It reads, "*⁸Owe no man any thing, but to love one another: for he that loves another has fulfilled the law. ⁹For this, you shall not commit adultery. You shall not kill. You shall not steal. You shall not bear false witness. You shall not covet: and if there be any other*

commandment, it is briefly comprehended in this saying, namely, you shall love your neighbor as yourself. Love works no ill to his neighbor: therefore love is the fulfilling of the law." Paul is saying here, "Owe no man anything." If you are indebted to someone, pay them. A lingering debt can cast a dark shadow over you and characterize you as being dishonest and not truthful. We are the light of the world, "**Let your light so shine that others can see the good work and glorify our father which is in heaven.**" (Matthew 5:16) Jesus commanded us to "Love one another. When we love one another, we fulfill the requirements of the law." When we love we don't have a desire to commit adultery with the neighbor's husband or wife. We won't kill, steal, or lie on someone; and we won't be jealous of another person's possessions or accomplishment. When we love, we will forgive. Love conquers a multitude of faults. When we love we won't do anything to harm our neighbors, our brethren or anyone. Love is fulfilling the law.

Romans 13:11-14 *Dake KJV*

Verses 11-14 reads, "**And that, knowing the time, that now it is high time to awake out of sleep: for now is our salvation nearer than when we believed. **[12]**The night is far spent, the day is at hand: let us therefore cast off the works of darkness, and let us put on the armor of light. **[13]**Let us walk honestly, as in the day; not in rioting and drunkenness, not in chambering and wantonness, not in strife and envying. **[14]**But put you on the Lord Jesus Christ, and make not provision for the flesh, to fulfill the lusts thereof.**" Paul is saying here, "Now is not a time for us to be sleeping—WAKE UP!" Salvation is closer than when we first believed. If there is ever a time that you must prove yourself, it is now. The night is growing old and the day is at hand: Put away works of darkness and stand with the armor of light on. Walk honestly as if it is day all the time. Don't riot, get drunk, and be involved in prostituting yourself or soliciting prostitutes, involving yourselves in deviant sexual behaviors, and all types of filthiness; or anything involving strife and envy. Put on the Lord Jesus Christ. He is the only one that can make you right with him. Don't make plans to fulfill the lust of your flesh, instead nourish your mind with the Word of God. When you know that your flesh is weak and lusting for something, don't entertain your flesh by feeding your thoughts with the wrong thing. You will deceive yourself. If you have been truly born again, by the power of the Holy Spirit, you have the power to conquer sin in your life.

Today's Relevance

To sum up what Paul taught here, Christians have responsibilities in and outside the church, in our community, in our neighborhoods. God has given us the responsibility to be good citizens and to be a light to our community. Paul said that when we fail to be good citizens, we disobey God. We have local, state, federal governments and officials that have rule over us. We are to respect our laws and governing officials. If we resist their power and the laws that are in place, we are not only disobeying them, but we are disobeying God and will bring punishment upon ourselves. Paul says, *"Obey those that have rule over you and you won't have to fear them if you are doing what is right. They are not there to terrorize you."* In this life, we are subject to bad leadership just as Israel was. What we have to understand is that God is still the ultimate authority. If we do our part, He'll do the rest. II Chronicles 7:14 sums it up, ***"If my people who are called by my name will humble themselves, and pray, and seek my face, and turn from their wicked ways, then will I hear from heaven, forgive their sins and heal the land."*** I believe that this command is as personal as it is national or global. If an individual lacks anything; if he/she needs healing in their body, if their home is dysfunctional, they have trouble on the job, etc. they should start by following those directions.

In America, we are blessed to have a democratic form of government. One of the good things about having this kind of government is that we have the freedom to vote. From time to time, there are those leaders who abuse their power. When they do, when they oppress, together we can do something about it. We have legal means to protest and demand changes in our system that we believe to be unfair or unjust. Voting is our voice. It is not just our civic duty to vote, but it is a God-given-right and we have a duty to do so. People have fought, bled and died for us to have the right to vote; therefore it is more than a privilege, but a responsibility. We must do our best to do what we can to keep our society organized, free of oppression, and criminal activity, etc. We are to honor God and thank Him for the privileges that He has blessed us with. We vote because we care about ourselves, our community and our children's future. When we don't fulfill our responsibility as we should, then we and future generations will suffer the consequences. We should not be complacent, disinterested in what is going on around us and wait for someone else to solve our problems. We are to be active participants in our own future. Sometimes Satan sends along a distraction to keep us from doing the right thing, but if we learn to do what we are suppose to do and trust God, when we do our best, He will do the rest. Election results alone do not determine how well we live, because God is our refuge and our strength.

Quiz for Romans 13

Select the best answer from the multiple choice items.

1. God warned the people of the Old Testament what to expect from human leadership. They were to understand that they would sometimes endure
 a. Oppression
 b. Bad leadership
 c. Unjust decisions
 d. Both a and b
 e. All of the above

2. In Chapter 13 the Apostle taught men to
 a. Worship idols
 b. Obey governing authorities
 c. Not obey oppressive leaders
 d. Resist authority
 e. Both b and c

3. Authorities that exist are
 a. Appointed by God
 b. Not appointed to be a terror to good works
 c. ministers from God
 d. For our good and our protection
 e. All of the above

4. Love works no ill to his neighbor, therefore love is
 a. The ultimate sacrifice
 b. Judging righteously
 c. The fulfilling of the law
 d. All of the above

5. The Bible is being fulfilled and time is closer than it was at the writing of Romans. The scripture advises us to
 a. Wake Up! Make plans for a place to hide

 b. Put on the Lord Jesus Christ

 c. Wake Up! Make no provision for the flesh to fulfill the lust of it

 d. Both b and c

6. Even when leaders are a terror to mankind, the scripture advises the people to

 a. Honor them

 b. Pay their taxes

 c. Fear them because they have rule over you

 d. All of the both

ROMANS 14

IRRELEVANT DOCTRINE

Points Covered

- Do not judge another man's servant
- The Kingdom of God is not meat or drink
- The conscience should be properly won by teaching the truth.

Romans 14:1-4 *NCV*

Paul teaches Christians how to treat fellow Christians whose faith is weak or immature. Sometimes we are confronted with doctrines or ideas that are not relevant to salvation, so Paul teaches us how to deal with them in the Church. Romans 14:1-4 NCV read, "***Accept into your group someone who is weak in faith, and do not argue about opinions. ²One person believes it is right to eat all kinds of food. But another, who is weak, believes it is right to eat only vegetables. ³The one who know that it is right to eat any kind of food must not reject the one who eats only vegetables. And the person who eats only vegetables must not think that the one who eats all foods is wrong, because God has accepted that person. ⁴You cannot judge another person's servant. The master decides if the servant is doing well or not. And the Lord's servant will do well because the Lord helps him do well.***"

How often have you been sidetracked from the truth or the real issue at hand by something that was irrelevant? These are just distractions from the real truth. Satan uses them and when he does, they become fatal distractions. They are false, misleading and causes us to lose valuable time from teaching. Paul says, "*One man is a vegetarian and believes that it is wrong to eat meat and the other eats all kinds of food. Accept those that are weak in the faith into*

your group. God has accepted him, who are you to judge the Lord's servant?" He is his Master and has the power to help him stand.

Group Discussion: Discuss a situation today that you may be familiar with in which a person was judged by the church or someone in the church and turned away or left because of it.

Romans 14:5-6 *NCV*

"*⁵Some think that one day is more important than another, and others think that everyday is the same. Let all be sure in their own mind. ⁶Those who think one day is more important than other days are doing that for the Lord. And those who eat all kinds of food are doing that for the Lord, and they give thanks to God. Others who refuse to eat some foods do that for the Lord, and they give thanks to God.* In the New Testament, there is no particular day to worship. Christians worship on Sunday, the first day of the week, because it was the first day of the week that Jesus appeared to His disciples after His resurrection. See St. John 20:19. There are those that still worship on Saturday, the seventh or Sabbath day which was a holy day in the Old Testament. Perhaps someone worships on another day, or regards everyday for worship, nevertheless, let us not waste time arguing about them. Paul says, "What ever day one regards as a day for worship he regards it to the Lord and the one that does not regard a day does not regard the Lord. If a man believes that God has blessed all kinds of food and made it fit for consumption, he eats and gives thanks to the Lord. Whoever refuses to eat certain foods do it for the Lord, also, and gives thanks to Him.

Romans 14:7-9 *NCV*

Verses 7-9 read, *⁷We do not live or die for ourselves. ⁸If we live, we are living for the Lord, and if we die, we are dying for the Lord. So living or dying, we belong to the Lord. ⁹The reason Christ died and rose from the dead to live again was so he would be Lord over both the dead and the living."* "No man is an island, no man stands alone." As Christians, we are not to live to ourselves. We are our brother's keeper. We have a responsibility to reach the loss for Christ, to fellowship with and help our sisters and brothers in the faith and live our lives as a sacrifice, holy and acceptable before the Lord. Living or dead, we belong to the Lord. We are His workmanship, His creation. We do not live or die for ourselves. When we die,

we die for the Lord, knowing that one day we will be changed from a mere mortal to an immortal. Christ died and was resurrected so that He might be Lord of both – living and dead. He is the model for the Christian. I Thessalonians 4:16 says, "*For the Lord himself shall descend from heaven with a shout, with the voice of the archangel, and with the trump of God: and the dead in Christ shall rise first:*"

Romans 14:10-12 *NCV*

In Verses 10-12, Paul says, "*So why do you judge your brothers or sisters in Christ? And why do you think you are better than they are? We will all stand before God to be judged, ¹¹because it is written in the Scriptures: As surely as I live, says the Lord, Everyone will bow before me; everyone will say that I am God.' So each of us will have to answer to God.*" In other words, "Why do you judge your brother and sisters? It is written in the scriptures that we should not judge." Jesus taught us not to judge one another in St. Matthew 7:1, "*Judge not, lest you be judged. For with what judgment you judge, you shall be judged and with what measure you mete, it shall be measured unto you.*" Even though we know that, we still have a tendency to look at others and judge them, we forget about our own faults. Paul says, "This shows that you think you are better than them," When in reality you could have a fault worst than theirs. Because your focus is on them, you can hide your own faults in your subconscious and forget about them. We will all stand before the judgment seat of God one day and we will give account of ourselves to Him. We have to remember Philippians 2:10-11, "*...every knee will bow and every tongue will confess that Jesus is Lord.*" We cannot hide from Him. He sees every man and the content of his heart.

Romans 14:13-16 *NCV*

Verses 13-16 continue, "*For that reason we should stop judging each other. We must make up our minds not to do anything that will make another Christian sin. ¹⁴I am in the Lord Jesus and I know that there is no food that is wrong to eat. But if a person believes something is wrong, that thing is wrong for him. ¹⁵If you hurt your brother's or sister's faith because of something you eat, you are not really following the way of love. Do not destroy someone's faith by eating food he thinks is wrong, because Christ died for him. ¹⁶Do not allow what you think is good to become what others say is evil.*" We should each make up our mind not to do anything that will cause another brother or sister to sin. It is a good idea

if we do a self-evaluation and then we won't be quick to judge others. Sometimes we are guilty of putting the magnifying glass over others and making them feel uncomfortable. We should not do this because it may cause them to err and concentrate on satisfying men, rather than being convinced in their heart by God's truth. You then cause them to sin. Do not destroy their faith by putting food in front of them that they think is wrong. Christ died for them like he did for you. Whether a man eats pork or not is not important to his salvation.

Romans 14:17-21 *NCV*

17In the kingdom of God, eating and drinking are not important. The important things are living right with God, peace, and joy in the Holy Spirit. 18Anyone who serves Christ by living this way is pleasing God and will be accepted by other people. 19So let us try to do what makes peace and helps one another. 20Do not let the eating of food destroy the work of God. All foods are all right to eat, but it is wrong to eat food that causes someone else to sin. 21It is better not to eat meat or drink wine or do anything that will cause your brother or sister to sin. The kingdom of God is not about what we eat and drink, but about living righteous with God, in peace, and joy in the Holy Ghost. We serve Christ better by living in a way that is pleasing to God. His second great commandment was that we love one another. If we love one another and strive to help each other, we won't let food and drink destroy the work of the Lord. Even though God has cleansed all food for consumption, until a person has been fully persuaded in his own mind, it is better that they not eat or drink what offends them otherwise they sin. Don't try to influence them by eating or drinking what offends them in their presence, because you may cause them to sin. Anything that is done without believing it is right is a sin. Don't let your good be evil spoken of.

Romans 14:22-23 *NCV*

22Your beliefs about these things should be kept secret between you and God. People are happy if they can do what they think is right without feeling guilty. 23But those who eat something without being sure it is right are wrong because they did not believe it was right. Anything that is done without believing it is right is a sin." In verses 22-23 Paul addresses the one who restricts their diet to only certain foods— vegetarians, no pork diets, etc., he

says, "If you have doubt about certain foods or drinks being fit for consumption, keep it between you and God. You will be much happier if you don't condemn yourself over things that are not specifically forbidden in scripture. If you have doubt that something is fit to eat, don't eat it until you are persuaded in your own mind that by faith it is clean. If you have faith, have it for yourself before God. Whatever is ***not*** done in faith is sin.

To sum up what he has taught, our responsibility as Christians to others who are weak in the faith is this, 1) Don't judge one another anymore, 2) If you judge, examine yourself and see you are guilty of putting a stumbling block in your brother's way that will cause him to fall, 3) Nothing is unclean of itself, but if a person has judged it to be unclean for them, then it is, 4) If a person is grieved by meat, be kind to him. Don't destroy him because of his belief. In other words, don't invite him to a pig-roasting cook-out if you know that he is vegetarian and will be offended. 5) Do not let your good be evil spoken of. The kingdom of God is not about meat and drink, but about righteousness, and peace, and joy in the Holy Ghost. **Righteousness** is living right with God, doing what you know is morally right before Him. If you love your neighbor as you do yourself, you will know what that is. Strive for **peace** with all men and experience **joy** in the **Holy Ghost**. Whoever has these three things are accepted by God and by men, 6) Follow after the things that make peace, and things with which you can edify or build up one another. Meat does not destroy God's work. All things are pure; but it is wrong for a man to eat it if it offends him. The conscience should be won by properly teaching the truth and not by trying to force one to accept it. If what you are doing is causing strife or tearing down a person, then you don't want to do it. Evaluate yourself and make sure that you are not the reason people are walking away from the Church. It is the job of believer's to build up the body of Christ.

Today's Relevance

Have you ever tried to change a person's mind or convince them of something you believe in? You've probably found that it is futile most of the time, but depending upon how influential you are you might be more successful than others. Let us not worry too much about the ones that are weak in the faith, but pray for them. God has the power to change a person's heart and mind so that there is no doubt. Let us compel others to come into the body of Christ. Let us teach and avoid adding unnecessary doctrine to the church which enslaves people. We must study so that we are not adding things to it or taking away things from God's Word. II Timothy 2:15 says, "***Study to show yourself approved to God, a workman that needs not to be ashamed, rightly dividing the word of truth.***" We

cannot teach what we have not studied. We should be able to refer to the chapter and verse of the Bible when teaching others so that they can read it for themselves. Teach what is necessary for salvation and let God do the converting. Stick to the scriptures and trust God to draw men in His own timing. He will pierce their conscience and lead them in the right direction. Have faith, knowing that what you teach or preach will not go out and return void.

Quiz -- Romans 14

Answer **True** or **False** and select the best choice.

1. In Chapter 14, we are taught how to deal with individuals who join the faith and hold on to other doctrine or beliefs that is
 a. Relevant to salvation
 b. Not relevant to salvation
 c. Necessary for the church to grow
 d. Conflicting with God's commandments

2. Christians are not to
 a. Eat pork
 b. Be a vegetarian and be weak in the faith
 c. Judge another man's servant
 d. Eat any kind of meat

3. Arguing about issues that are not relevant to salvation is
 a. A distraction from the real truth
 b. A waste of time
 c. Not fruitful
 d. All of the above

4. Christians are not to live to themselves, but to
 a. Reach the loss for Christ
 b. Help one another
 c. Live lives that are pleasing to God
 d. All of the above

5. When we judge our sisters and brothers, we are
 a. Thinking we are better than they are
 b. Judging righteously
 c. Helping them come closer to God
 d. Showing how much we love them

ROMANS 15

CHRISTIAN DISCIPLINE

Points Covered

- Learn to be patient.
- The strong in faith should bear the weaknesses of those that are weak.
- Study the scriptures and stick to what is written for your learning.
- Jews and Gentiles are to become one in the worship of God, being equal in His mercies and grace.
- Beware of those that cause divisions and offences contrary to the doctrine you've learned and avoid them.

It is a real challenge putting up with the behavior of people that are immature. Sometimes we forget how far along we've come and that at some point we were immature in the faith. I have to remind myself that I didn't get to where I am today instantly. It was through trials and tribulations, and turning to God that I've matured, but I occasionally have to remind myself to be patient with others. In this chapter the Apostle Paul teaches Christians how to treat other Christians who are weak or immature in the faith. He begins Romans 15:1-3 like this, "*We who are strong in faith should help the weak with their weaknesses, and not please only ourselves. ²Let each of us please our neighbors for their good, to help them be stronger in faith. ³Even Christ did not live to please himself. It was as the Scriptures said: "When people insult you, it hurts me.*" In other words, Paul is saying, we who are strong in the faith are to be patient and help those that have not learned Christian discipline. They are weak in the faith. Immaturity is weakness, but we grow in grace. Not everything is about proving you are right, but being patient with others and allowing them to grow. The Apostle says you must take the time to please your neighbors and help them grow stronger. Christ is our role model so let us do as He did. He did not live to please Himself, but the

Father. We must live to please Him, to encourage and build others up that they might grow stronger. People will say things that hurt us, and it hurts Christ when they do. We have to know that He always has us in mind so we are to do as Galatians 6:9 says, "***And let us not be weary of well-doing: for in due season we will reap, if we faint not.***"

Romans 15:4-7 *NCV*

*⁴**Everything that was written in the past was written to teach us. The Scriptures give us patience and encouragement so that we can have hope. ⁵May the patience and encouragement that come from God allow you to live in harmony with each other the way Christ Jesus wants. ⁶Then you will all be joined together, and you will give glory to God the Father of our Lord Jesus Christ. ⁷Christ accepted you, so you should accept each other, which will bring glory to God.*** The scriptures in the past and now have been written to teach us patience and encourage us so that we can have hope. Those same scriptures teach us to love one another and to live in harmony according to the standards of Christ Jesus. If we did this we would not have all of the evil things happening that we read about in our newspapers and hear about on television today. Just think about that, we wouldn't have murder, wars, rape, stealing, etc. Each man would respect the other and his belongings. This would please God and together we could give glory to God the Father. Just as Christ looked beyond our faults, saw our need and accepted us, we should try to do likewise for each other.

Romans 15:8-12 *NCV*

⁸I tell you that Christ became a servant of the Jews to show that God's promises to the Jewish ancestors are true. ⁹And he also did this so that those who are not Jews could give glory to God for the mercy he gives to them. It is written in the Scriptures: "So I will praise you among the non-Jewish people. I will sing praises to your name." ¹⁰The Scripture says, "Be happy, you who are not Jews, together with his people." ¹¹Again the Scripture says, "All you who are not Jews, praise the Lord. All you people, sing praises to him." ¹²And Isaiah says, "A new king will come from the family of Jesse. He will come to rule over the non-Jewish people, and they will have hope because of him." To fulfill the promises made to Abraham, Isaac, Jacob, David and the other prophets, Jesus Christ humbled Himself and became a servant to confirm that what they spoke was truth. He fulfilled the promises He made to their Jewish ancestors, the ones called the fathers. It is written in Genesis 18:18, "***Seeing***

that Abraham shall surely become a great and mighty nation, and all the nations of the earth shall be blessed in him?" It is written by the prophet Isaiah "*There shall be a root of Jesse, and he shall rise to reign over the Gentiles*." Jesse was the father of David, the family roots through which Jesus came into the world. Because of God's great mercy, the Gentiles, the non–Jews, can glorify Him for they are blessed to be included in His grace. They should rejoice, praise Him forever. He didn't have to do it, but He did. In Him should the Gentiles trust, because he gave them hope, hallelujah! I'm a living witness that you can trust Him.

Romans 15:13-16 *NCV*

"*13I pray that the God who gives hope will fill you with much joy and peace while you trust in him. Then your hope will overflow by the power of the Holy Spirit. 14My brothers and sisters, I am sure that you are full of goodness. I know that you have all the knowledge you need and that you are able to teach each other. 15But I have written to you very openly about some things I wanted you to remember. I did this because God gave me this special gift: 16to be a minister of Christ Jesus to those who are not Jews. I served God by teaching his Good News, so that the non–Jewish people could be an offering that God would accept—an offering made holy by the Holy Spirit*. Here Paul encourages brothers and sisters of the faith. He says, "I pray for you that God will fill believers that trust Him with much hope, joy and peace and that by the power of the Holy Ghost your hope will over flow. Remember the Holy Ghost, the 3rd person in the Trinity. He is the agent that teaches and empowers us to live righteously. Paul said, "I am persuaded that my brothers and sisters in Christ are full of goodness, filled with knowledge and able to teach one another the way of the Lord. In other words, he is saying, "*I know that you are good people and I'm confident that you have the knowledge to teach others.*" He went on to say, "*God gave me a special gift to minister to the non Jews. With His authority, I have written you very openly about things that I strongly advise you to remember. I serve God by teaching the gospel to the Gentiles so that they can be an offering made holy by the Holy Spirit that God would accept.*" (See John 16:11-17 role of Holy Spirit)

Romans 15:17-21 *NCV*

"*17So I am proud of what I have done for God in Christ Jesus. 18I will not talk about anything except what Christ has done through me in leading those who are not Jews to obey God. They have obeyed God because of what I have said and done, 19because of the power of*

miracles and the great things they say, and because of the power of the Holy Spirit. I preached the Good News from Jerusalem all the way around to Illyricum, and so I have finished that part of my work. ²⁰I always want to preach the Good News in places where people have never heard of Christ, because I do not want to build on the work someone else has already started. ²¹But it is written in the Scriptures: "Those who were not told about him will see, and those who have not heard about him will understand." Here Paul reflects on his own work saying, *"I'm proud of the work that I've done for Christ and I won't waste time talking about anything except what Christ has done through me in leading those that are not Jews to obey God."* Have you ever helped someone and afterwards, you felt this sense of satisfaction and just wanted to tell someone else, not to brag, but to share. I believe that this is what Paul felt here. He felt a sense of satisfaction in his work because he could see results. As he preached the gospel, people believed and received it because of the miracles, and other great things achieved under the power of the Holy Ghost. Paul preached from Jerusalem to Illyricum and now that he was finished with that part of his work, he said, "I enjoy preaching the gospel in places where people have never heard of Christ. I prefer not to build on the work someone else has started. In Verse 21, he quotes Isaiah 52:15, *"...those who were told about him will see, and those who have not heard about him will understand."* God knows better than we do how many times a man has to hear the gospel before he responds and to what he responds to. While someone may have already preached the gospel in Rome, there is still someone who has not heard in a spiritual sense. In the same way that the Apostle spoke in I Corinthians 3:6 NIV, *"I planted the seed, Apollos watered it, but God has been making it grow."* Paul was not the one to plant the seed, but the one to go into Roman and water it. His preaching and his anointing broke the yoke that held someone else captive and many more hearts were won for the sake of the gospel. There will come a day when the gospel will have been preached around the world and it will be clear to everyone. Every knee will bow and every tongue will confess that Jesus is Lord.

Romans 15:22-29 *NCV*

Paul continues, *"This is the reason I was stopped many times from coming to you. ²³Now I have finished my work here. Since for many years I have wanted to come to you, ²⁴I hope to visit you on my way to Spain. After I enjoy being with you for a while, I hope you can help me on my trip. ²⁵Now I am going to Jerusalem to help God's people. ²⁶The believers in Macedonia and Southern Greece were happy to give their money to help the poor among God's people at Jerusalem. ²⁷They were happy to do this, and really they owe it to them.*

These who are not Jews have shared in the Jews Spiritual blessings, so they should use their material possessions to help the Jews. ²⁸After I am sure the poor in Jerusalem get the money that has been given for them, I will leave for Spain and stop and visit you. ²⁹I know that when I come to you I will bring Christ's full blessing. In Chapter 1 of Romans, Paul made mention of the fact that he planned many times to come to Rome, but the work he was doing where he was and the fact that he did not like building on the work that someone else started and that was what prevented him from coming. God is in complete control of everything. Paul was His chosen vessel to bring the gospel to the Gentiles. He knew that we need the instructions of the epistle of Romans. While it was intended for the converts in Rome, everyone generations to come needed the revelation of what was a mystery. The book of Romans is described as the most complete presentation of the Christian faith. The Lord placed a burden of responsibility on Paul's heart and he wrote this epistle (letter) to the Romans preparing them for the time that he would come. Now that his work in the area is finished, he writes, "*I am now on my way to Jerusalem to help God's people by bringing to them relief or charitable contributions from the Churches of Macedonia and Southern Greece. They were happy and willing to help the Jews and should be, because they share in the Jews Spiritual blessings.*" He continued, "*When my work in Jerusalem is complete, I will leave for Spain and stop by and visit you. I'm confident that when I come, God's full blessings will come with me.*"

Romans 15:30-33 *NCV*

³⁰Brothers and sisters, I beg you to help me in my work by praying to God for me. Do this because of our Lord Jesus and the love that the Holy Spirit gives us. ³¹Pray that I will be saved from the nonbelievers in Judea and that this help I bring to Jerusalem will please God's people there. ³²Then, if God wants me to, I will come to you with joy, and together you and I will have a time of rest. ³³The God who gives peace be with you all. Amen. Paul's life had been endangered many times by people who did not believe in Jesus or Christianity, so he is asking the saints of the church in Rome to pray for his safety and that he will be able to complete his mission in Jerusalem and that the people might be richly blessed. He further says that if it is God's will, I will gladly come to you and I will be able to rest as well. He concludes Chapter 15 with, "**Now the God of peace be with you all. Amen**"

Quiz -- Romans 15

Answer **True** or **False** or select the best answer.

1. **True** or **False**. Christians who are strong in the faith should chastise the weak so they can grow.

2. Scriptures give us
 a. Past and present humility
 b. Patience and encouragement
 c. Trials and tribulation
 d. Glory and honor

3. Christ became a servant of the Jews to show
 a. How mighty and powerful He is
 b. That He was angry with the Gentiles
 c. That God's promises to them are true
 d. None of the above

4. At the time of the Apostle Paul's writing of the Roman epistle he was in ____.
 a. Illyricum
 b. Corinth
 c. Spain
 d. Egypt

5. God placed a burden on Paul's heart to
 a. Write a letter to the church in Illyricum
 b. Write a letter to the church in Jerusalem
 c. Write a letter to the church in Rome
 d. Write a letter to the church in Palestine

6. God gave Paul a special gift, to be minister a of Christ Jesus to the
 a. Egyptians
 b. Europeans

 c. Hebrews

 d. Gentiles or Non Jews

7. Paul's plans were to go to Jerusalem and leave gifts for the poor sent by the Gentiles and on his way to Spain he would

 a. Stop in Macedonia to pray for the sick

 b. Stop in Rome to bring Christ's full blessing

 c. Stop in Greece to feed the poor

 d. Stop in Egypt to witness for Christ

8. **True** or **False**. For many years Paul wanted to visit Rome but was delayed because he was busy making tents to sell.

ROMANS 16

COMMENDATIONS AND EXHORTATIONS

Points Covered

- Recommended Phoebe, and acknowledges other women in the church
- Acknowledged other men that worked with him on his mission
- Exhorts and encourages unity in the body of Christ.
- Taught the church to stick to sound doctrine.
- Handling those who go contrary to doctrine and cause divisions.

Romans 16:1-2 *NKJV*

"*I commend to you Phoebe our sister who is a servant of the church in Cenchrea, ²that you may receive her in the Lord in a manner worthy of the saints, and assist her in whatever business she has need of you; for indeed she has been a helper of many and of myself also.*" The Apostle Paul is doing here what he encouraged believers to do, "Exhort one another daily." He sent greetings to various people of the faith with whom he had worked that had moved back to Rome. In verses 1 and 2 he commended Phoebe to the church in Rome. Phoebe was a deaconess in the Church of Cenchrea and a succourer (one who takes in strangers; or gives help in time of need). She apparently provided housing and made provision for the apostles (including Paul) and other ministers who came to Cenchrea and may have been the one who Paul entrusted the delivery of this letter to the Romans since he ask them to receive and help her. A point that is often debated is that he instructed women to keep silent in the church (I Corinthians 14:34-35). However, if Paul meant all women in the church should keep silent why then is he here encouraging the church to receive Phoebe

and assist her in whatever she needs? Was he talking about all women everywhere or was he addressing a situation in Corinth? If he meant all women, why does he not mention single and widowed women? This leaves us to reason that he was dealing with a situation in the church that involved the wives. ***"Let your women keep silent...let them ask their husbands at home..."***

Romans 16:3-16 *NKJV*

"³Greet Pricilla and Aquila, my fellow workers in Christ Jesus, ⁴who risked their own necks for my life, to whom not only I give thanks, but also all the churches of the Gentiles. ⁵Likewise greet the church that is in their house. Greet my beloved Epae-net-us, who is the first fruits of Achaia' to Christ. ⁶Greet Mary, who labored much for us. ⁷Greet Andro-ni-cus and Junia, my countrymen and my fellow prisoners, who are of note among the apostles, who also were in Christ before me. ⁸Greet Am-pli-as, my beloved in the Lord. ⁹Greet Urbanus, our fellow worker in Christ, and Sta-chys, my beloved. ¹⁰Greet A-pell-es, approved in Christ. Greet those who are of the household of Aris-to-bu-lus. ¹¹Greet Herod-ion, my countryman. Greet those who are of the household of Nar-ciss-us who are in the Lord. ¹²Greet Tryphena and Tryphosa, who have labored in the Lord. Greet the beloved Persis, who labored much in the Lord. ¹³Greet Rufus, chosen in the Lord, and his mother and mine. ¹⁴Greet Asy-ne-ritus, Phlegon, Hermas, Patrobas, Hermes, and the brethren who are with them. ¹⁵Greet Phi-o-lo-gus and Julia, Ne-reus and his sister, and Olympas, and all the saints who are with them. ¹⁶Greet one another with a holy kiss. The churches of Christ greet you." Throughout this passage the Apostle mentions both men and women who have labored and suffered with him in promoting the gospel. Some of whom were Christians before him and some who were imprisoned with him and then he ends it with, "Greet one another with a holy kiss." It was a custom of Christians in that day to greet each other with a kiss, as a token of peace and friendship. The word *holy* means spiritually pure; sinless.

Group Discussion

How should you handle a brother or sister in the church who always seem to be at the center of conflict? Perhaps they criticize others for no good reason and complain or reject anything that the pastor does for the up building of the body of Christ. They seem to be at the center of controversy all the time.

Romans 16:17–18 *NKJV*

After Paul sent greetings to them, he admonished them to adhere to sound doctrine and unity in Spirit. Verses 17-18 reads, "*¹⁷Now I urge you, brethren, note those who cause divisions and offenses, contrary to the doctrine which you learned, and avoid them. ¹⁸For those who are such do not serve our Lord Jesus Christ, but their own belly, and by smooth words and flattering speech deceive the hearts of the simple.*" In other words, watch out for those who sow seeds of discord among you, because they divide and offend you in the church. I suggest that you avoid them. Another way of saying it is this, now that you have been taught how to behave as Christians, if you see someone in the body of Christ not following his way, don't follow them. Don't participate in their tactics, avoid them.

In teaching, Jesus often used metaphors, objects that people could relate to. In St. John 10:37, He said this, "*My sheep hear my voice, and I know them, and they follow me*." Jesus compared Himself to a shepherd and his followers to a flock of sheep. Shepherd and sheep or metaphors used as comparisons to Jesus, the Good Shepherd, and believers who unite with Him, sheep. Animal sheep have a strong lead-follow tendency. If worked with patiently, sheep can learn their names and recognize individual human faces, and remember them for years. Sheep are frequently thought of as unintelligent animals, but easy to train. The duty of shepherds was to keep their flock intact, protect it from wolves and other predators. The shepherd was also to supervise the migration of the flock. By comparison if we consider Jesus, the Good Shepherd, teaching, leading and guiding his flock and the flock that follows Him belongs to Him. They know His voice apart from all of the other shepherds. He knows them by name and they follow Him. They will not follow another voice that is not His. Individuals in the body of Christ that wear the name "Christian" and do evil does not belong to Him. They don't even know His voice and will not follow Him.

Sheep follow the shepherd and obey his commands. If they are not following and obeying Him, He knows it. He knows who belongs to Him and who doesn't. In St. Luke 13:27 "*But he will reply, 'I don't know you or where you come from. Away from me, all you evildoers!'* His way is the way of peace. In St. John 14:27, Jesus said, "*Peace I leave with you; My peace I give to you; not as the world gives do I give to you...*" Avoid those that spend their time upsetting others, creating divisions, and disturbing the peace, because they don't know Christ. There are those who have no respect for God, they use profanity in the church and carry guns to business meetings, avoid them. They are not His sheep. There is an old saying we hear sometimes to describe people that follow other people, "*Birds of a feather flock together.*" If you're one of His sheep, don't follow the goats. Beware of those that are out to satisfy their own desires. Be careful following those who are eloquent with words but what

they are saying doesn't line up with God's Word. Don't be deceived by them. They are blinded by their own ambition to be seen and heard. They don't know Christ.

Romans 16:19-20 *NKJV*

Verses 19- 20 read, "***For your obedience has become known to all. Therefore I am glad on your behalf; but I want you to be wise in what is good, and simple concerning evil. ***[20]***And the God of peace will crush Satan under your feet shortly. The grace of our Lord Jesus Christ be with you. Amen.***" Here the Apostle Paul praises them for their faithfulness in obeying God's Word. He says, "Everyone has heard about you and how loyal you are to the gospel and I'm happy about that, but I want you to be wise about what is good and not be tricked into doing things that are evil. God is our source of peace and according to prophecy will soon crush Satan under your feet. Satan will be defeated at the Second Advent and the end of the millennium. See Revelations 20:1-10. Paul says, "*I pray that the grace of the Lord Jesus Christ will be with you.*"

Romans 16:21-24 *NKJV*

Verses 21-23 read, "***Timothy, my fellow worker, and Lucius, Jason, and So-si-pater, my countrymen, greet you. ***[22]***I, Tertius, who wrote this epistle, greet you in the Lord. ***[23]***Gaius, my host and the host of the whole church, greets you. Eratus, the treasurer of the city, greets you, and Quartus, a brother. ***[24]***The grace of our Lord Jesus Christ be with you all. Amen.***" Paul sent greetings from Timothy, Lucius, Jason, So-si-pater, Eratus, and Quartus. Tertius, the one to whom Paul dictated the epistle of Romans, inserted his own salutation.

Romans 16:25-27 *NKJV*

Paul concluded the book of Romans with this benediction. Verses 25-27 read, "***[25]Now to Him who is able to establish you according to my gospel and the preaching of Jesus Christ, according to the Revelation of the mystery which was kept secret since the world began ***[26]***but now made manifest, and by the prophetic Scriptures made known to all nations, according to the commandment of the everlasting God, for obedience to the faith — ***[27]***to God, alone wise, be glory through Jesus Christ forever. Amen.***" You will find here what Paul stated

in his introduction, the purpose for which he has been chosen, to establish the gospel and the preaching of Jesus Christ. Establish means to *ordain or appoint permanently* (like a law or official); *to set-up or cause to be.* Paul had the job of putting the essentials for salvation into one book. He brought together God's commands, the scriptures of the prophets foretelling the coming of the Messiah, the fulfilling of that prophecy through Jesus Christ, and revealing how it works to save us. What was a mystery is now made manifest for the benefit of all nations for obedience for the faith. He concludes this epistle by acknowledging the everlasting God who is the only one wise and powerful enough to give us justification by faith through Jesus Christ forever. Forever means always or permanently. There will be no other plan to take its place. Don't believe anyone that tells you that God's plan for the salvation of mankind has changed or that there is another way. To God be the glory, Amen.

Quiz -- Romans 16

Answer **True** or **False** or select the best answer.

1. **True** or **False**. Paul acknowledged and commended men and women for their work in the church at Rome and for their support.

2. **True** or **False**. Paul instructed the church to stick to sound doctrine and not let women speak in the church.

3. Pheobe was
 a. A watchwoman for the church
 b. A judge for the church of Rome
 c. A deaconess in the church of Cenchrea
 d. A missionary on her way to Spain

4. Pricilla and Aquila was a couple who had labored with Paul. He called them
 a. Prophets
 b. Evangelists
 c. Preachers
 d. Fellow workers

5. After Paul's greetings and exhortations he told them all to
 a. Be steadfast and unmovable
 b. Greet one another with a holy kiss
 c. To pray
 d. Hug also the saints for him

6. Paul admonished the saints to stick to sound doctrine and avoid
 a. Those who cause divisions and offenses
 b. Talking with sinners
 c. Helping the pastor
 d. Women that talk too much

Bibliography

Abortion. http://bound4life.com. Bound4Life, 205 3rd Street S.E., Washington, DC 20003. Copyright 2013.

Centers for Disease Control Prevention. CDC 24/7: Saving Lives, Protecting People. 1600 Clifton Rd., Atlanta, GA 30333, USA.

Facts on Induced Abortion in the United States. In Brief. Copyright 1996-2008, Guttmacher Institute, http://www.guttmacher.org/pubs/fb_induced_abortion.html.

Good News Bible: Catholic Study Edition; Today's English Version translation; United Bible Societies Publisher; Copyright 1966.

Higle, Tommy C., Journey of a Lifetime; A 52 lesson Study of the Entire Bible; Lesson 31… The Book of Romans, P. 136.

Pictorial Bible Dictionary. Merrill C. Tenney, General Editor, Zondervan Publishing House, Copyright 1963, 1964.

The Holy Bible: Giant Print Edition: Containing Old and New Testaments; New Century Version (NCV); Nelson Bibles, A Division of Thomas Nelson Publishers; Copyright 2006.

The Dake Annotated Reference Bible: King James Version; Containing the Old and New Testaments; Finis Jennings Dake; Dake Publishing, Inc.; Lawrenceville, GA;

Webster's New World Dictionary of the American Language; Warner Books Paperback Edition; #1 Bestseller, Revised.

Worldometers. Real time world statistics. HIV/AIDS in the world. http://www.worldometers.info/aids/

ABOUT THE AUTHOR

Dr. Frances Wright-Harris has a Masters Degree in Education, a Doctor of Theology, and is an ordained minister. She is actively engaged in her church, her radio broadcast "***Getting to Know Your Bible***", a nursing home ministry, and speaking engagements proclaiming the gospel of Jesus Christ.